Panda Love

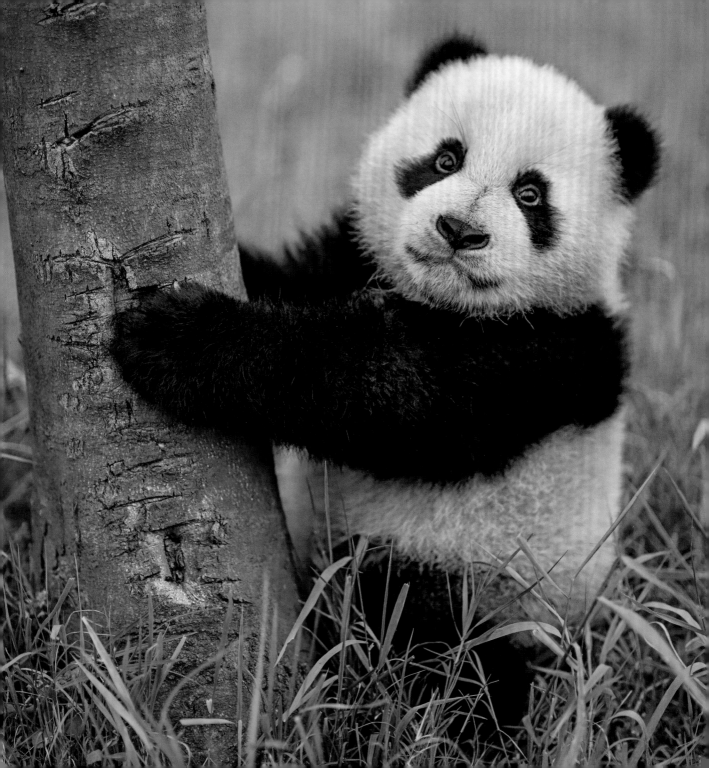

Panda Love

the secret lives of pandas

AMI VITALE

hardie grant books

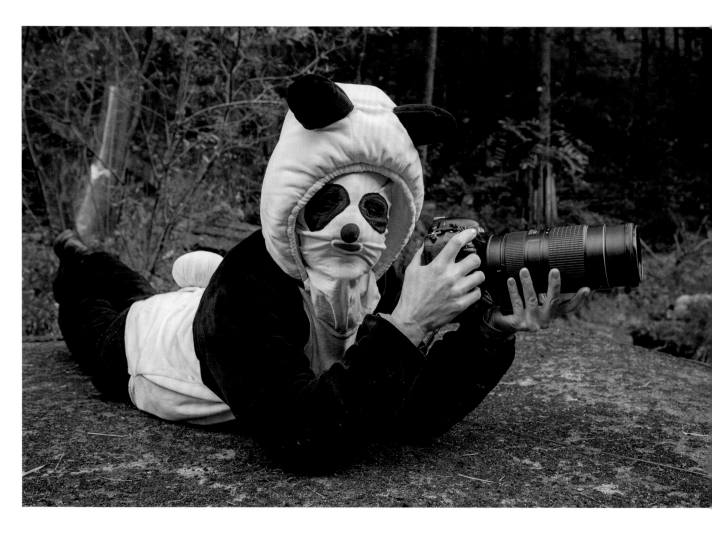

'In a world of seven billion people, we must see ourselves as part of the landscape. Our fate is linked to the fate of animals. Saving nature is really about saving ourselves. Can we re-imagine a world where all life is important?'

About the Author

Ami Vitale's journey as photographer, writer and filmmaker has taken her to 95 countries, where she has had the opportunity to witness life's extremes, from civil unrest and violence to the beauty and enduring power of the human spirit. She has lived in mud huts and war zones, contracted malaria and donned a panda suit – all in keeping with her philosophy of 'living the story.'

For her work with pandas, Vitale made multiple trips over three years to China, getting to know the people involved in panda conservation efforts along with the bears themselves – even learning to think like a panda.

Vitale came away with renewed confidence that those who care most about the animals are on the right path to save them – she says, 'there is still a great deal of effort, research, and melding of policy, law and science needed to perfect the process of re-wilding giant pandas and protecting the habitat they need to survive. As the work moves forward, I see a future China that proudly provides a home to a growing population of one of its greatest wild assets – the fanciful black-and-white bear that helps make the world a more balanced and beautiful place for us all.'

The recipient of many prestigious awards, Vitale is an ambassador for Nikon and a photographer and writer with *National Geographic* magazine. She is a founding member of Ripple Effect Images, an artists' collective focused on women's issues in developing countries. When not teaching, lecturing, or covering the planet's most pressing issues – from wildlife conservation to devastating human conflict – Vitale digs into the smaller but equally compelling stories that haven't yet been told, the 'stories within the story.' Occasionally, she goes home to Montana to rest.

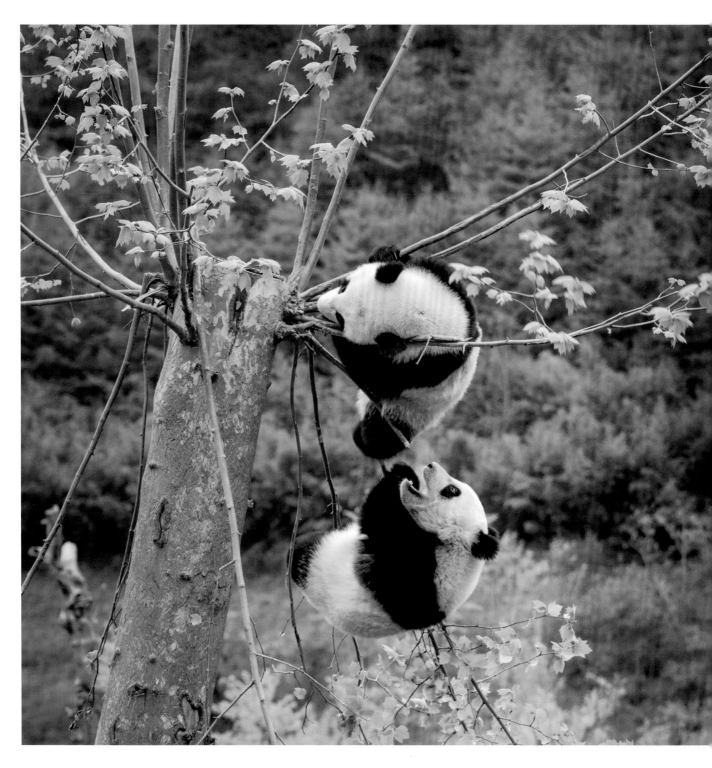

Introduction

In December 1936, a wild panda cub named Su-Lin was smuggled out of Shanghai in a wicker basket by a San Franciscan socialite named Ruth Harkness. She had an export permit reading, 'One dog, $20.00.' Soon after her return, the woman sold Su-Lin to a zoo. The West had only recently become aware of the noble giant panda after President Theodore Roosevelt's sons, Theodore and Kermit, shot one on an expedition in 1928. But Su-Lin was alive, and in Chicago for everyone to see. On the opening day of the exhibit more than 50 000 people came to see the panda.

Since then, the West has coveted the clownish, adorable animals. Zoos today pay millions of dollars to mount exhibits, and panda 'ambassadors' on loan from China never fail to attract a crowd.

But in the mist-drenched mountains of Liziping Nature Reserve in Sichuan Province, things are a little different. Here, getting close to a giant panda can be challenging, to say the least – we must never forget the 'wild' in wildlife. Working in the field, one is tempted to get up close and personal with the animals we want to highlight. But these interactions can have lethal consequences – for us and for the animals themselves. Their minders are very concerned about any interference with the notoriously finicky animal's biology or conservation and, let's not forget, they are enormous animals with teeth and claws.

The best and safest way to learn about any kind of wildlife is to keep your distance and be respectful. To get as much as I could of the story of their lives, I had to learn to blend in. So, to get close enough to take these photos, I needed to look and smell like a panda. I had to be suited-up in a panda costume

that was scented with panda urine and faeces, just like the staff would wear.

Right now, there are fewer than 2000 giant pandas in the wild. Their breeding secrets have long resisted the prying efforts of zoos, and the mountainous bamboo forests they call home have been decimated by development and agriculture. But in a region where bad environmental news is common, the future of the giant panda might prove to be the exception. For 30 years, researchers from the reserve have been working on breeding and releasing pandas, augmenting existing populations and protecting their habitat. And they're finally having success.

As well as helping with the difficult insemination process – female pandas are only fertile once a year, for only 24–72 hours – the researchers at The China Conservation and Research Center for the Giant Panda (CCRCGP) monitor the cubs, and once they're two years old, help ease them towards surviving in the wild. Eventually, they are moved to a large habitat in the mountains where a mother can coach her cubs in survival.

The pandas in these faraway mountains will have no lines of school children waiting to meet them, nor a fan page on Facebook. But as the great bears trundle off into the wild, they take with them hope for their species. The slow and steady incline in the population of giant pandas is a testament to the perseverance and efforts of Chinese scientists and conservationists. By breeding and releasing pandas, and protecting their habitat, China may be on its way to successfully saving its most famous ambassador.

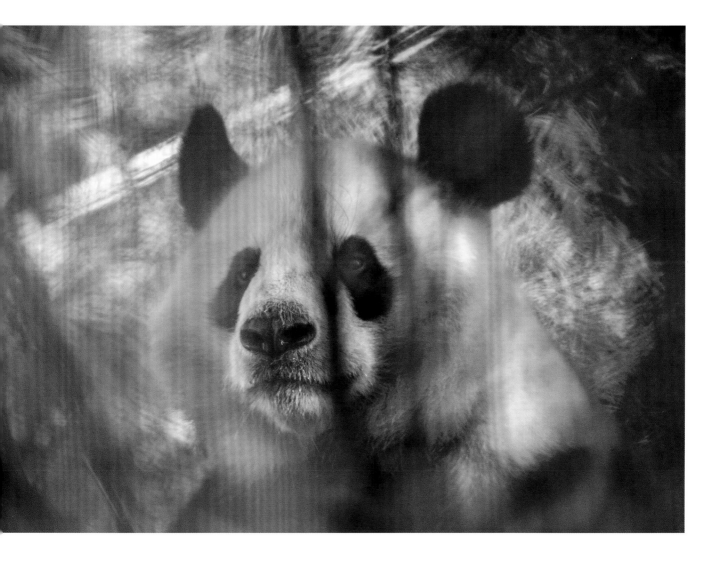

The giant panda might be
endangered, but researchers are
going to every length to help
these creatures thrive in the wild.

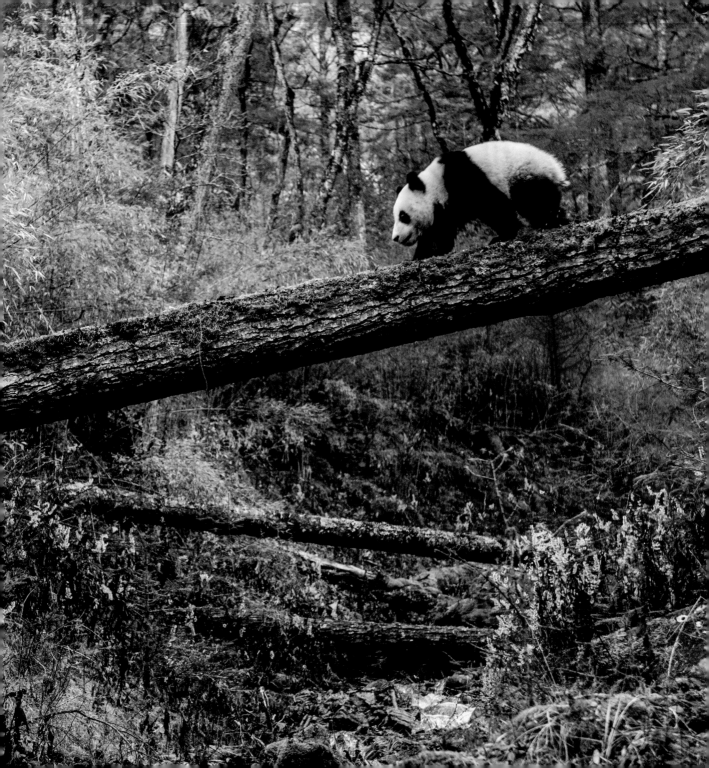

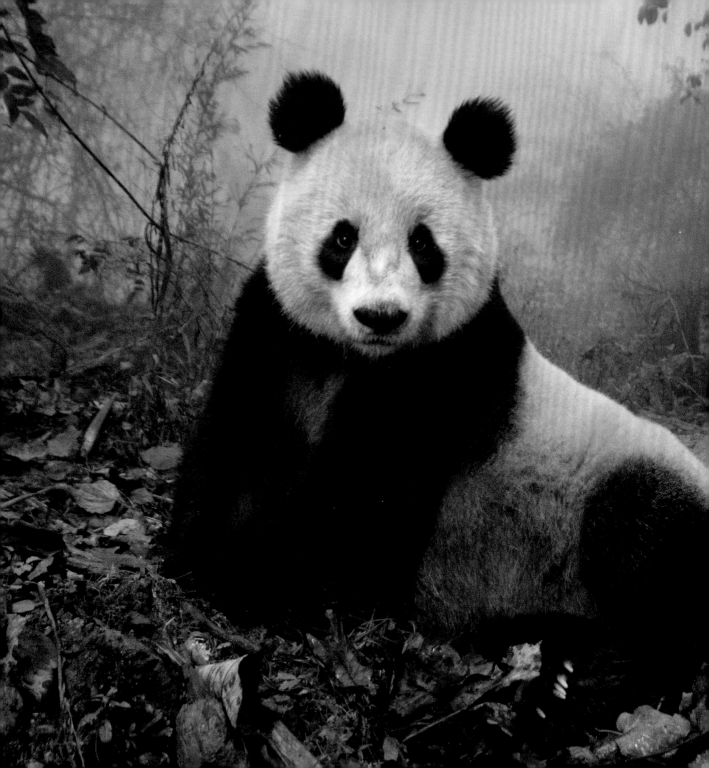

It's hard to imagine, but pandas were once as mythical and elusive as Bigfoot. Despite being around for millions of years, they were only made known to the Western world within the last century – the first panda was captured alive only in 1936.

Right How did they remain so elusive? In the wild, giant pandas are only found in the remote, mountainous regions of central China, in Sichuan, Shaanxi and Gansu provinces. In these areas, there are cool, wet bamboo forests that are perfect for the giant panda's needs – they like to camp out there, hidden from mankind.

Overleaf For millions of years, pandas survived on a diet of meat. Rather than compete with other predators, they changed their digestive system, behaviours and even their body shape to adapt to a diet comprised almost exclusively of bamboo. They even developed a 'sixth toe' that helps them grasp the bamboo better when they are eating. Each panda eats 13½–36 kgs (30–80 lbs) of bamboo a day.

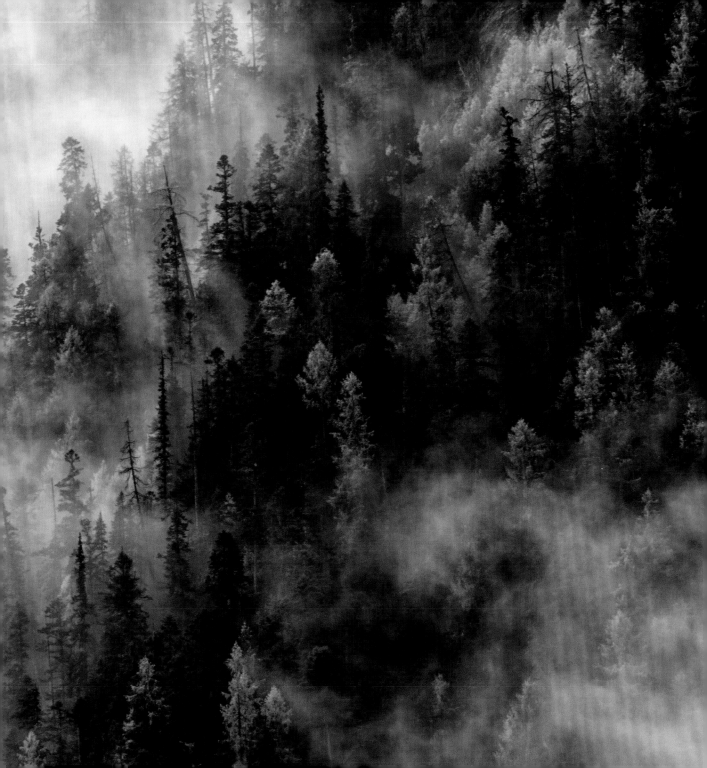

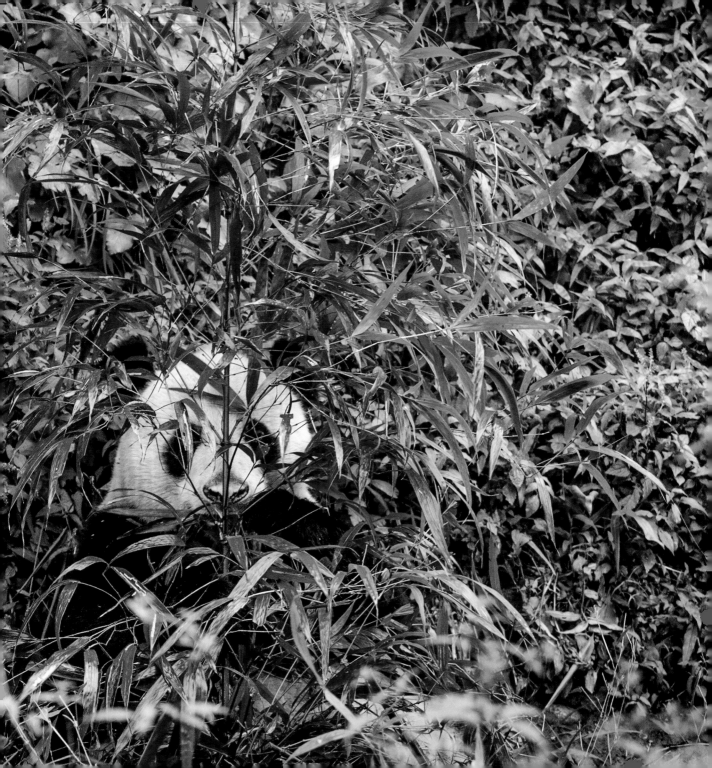

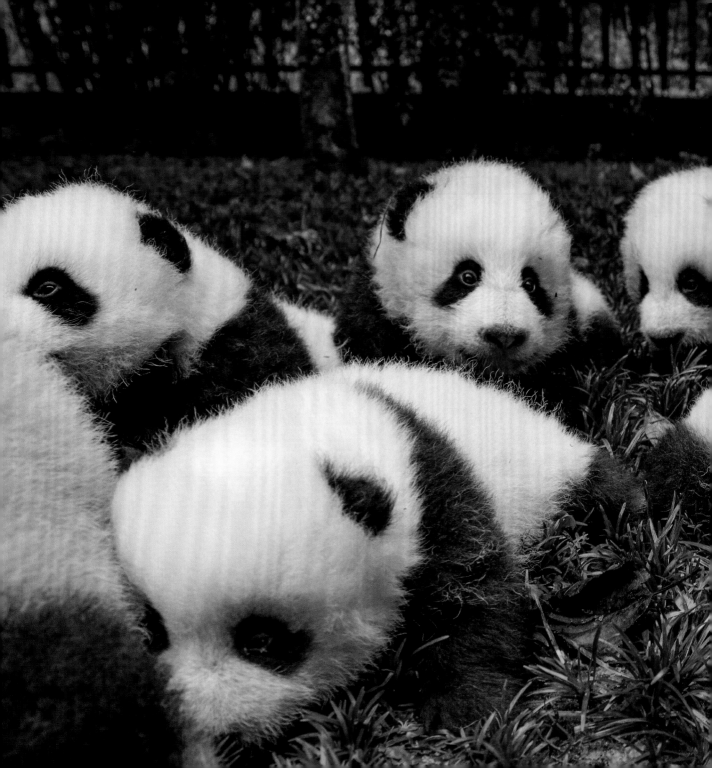

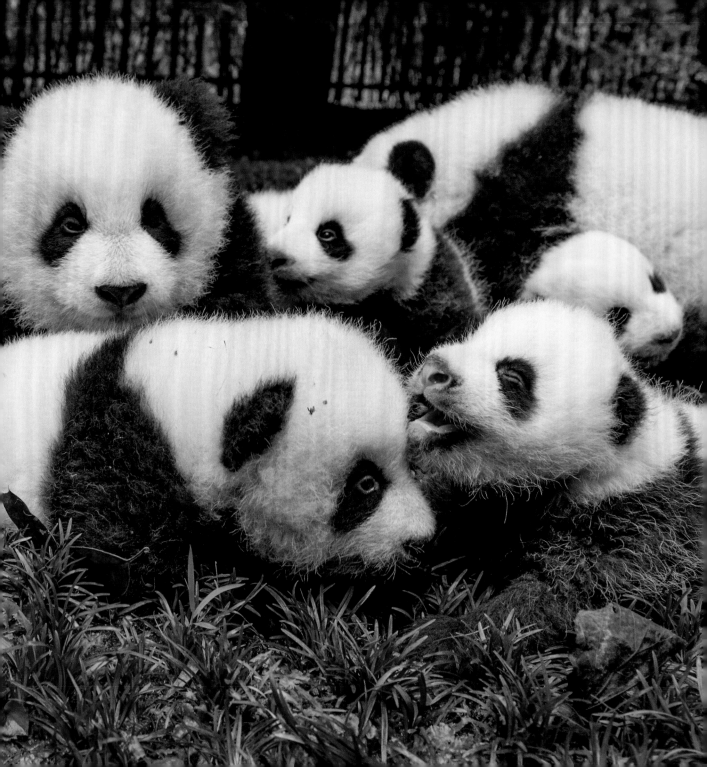

Giant panda cubs are adorable
fluffballs that squeak and squeal.
This endangered species has
also been incredibly tricky to
breed and raise in captivity. In
the 1960s, only 30 per cent of
infant pandas born at breeding
centres survived. Today, they have
cracked the code and the pandas
have a 90 per cent survival rate.

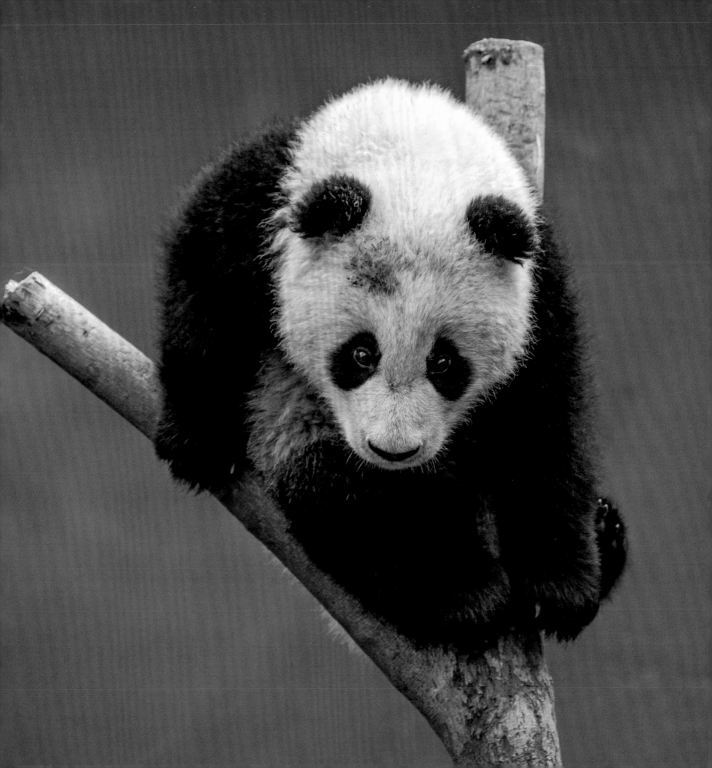

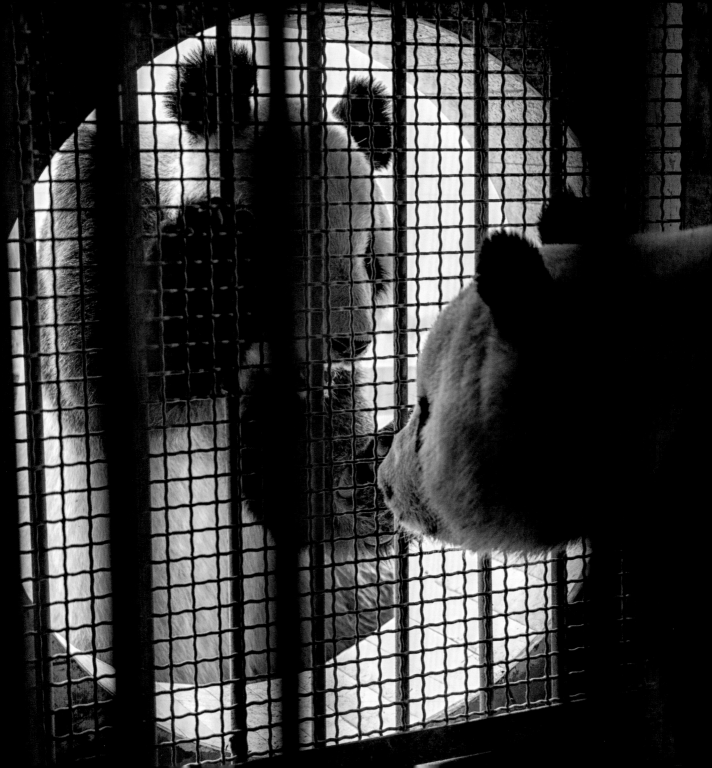

The challenge of breeding pandas in captivity is the incredibly short period of time that females are receptive to mating. They enter oestrus only once a year and are receptive and fertile for just 24–72 hours. A male panda needs to make his move then, or wait for another year.

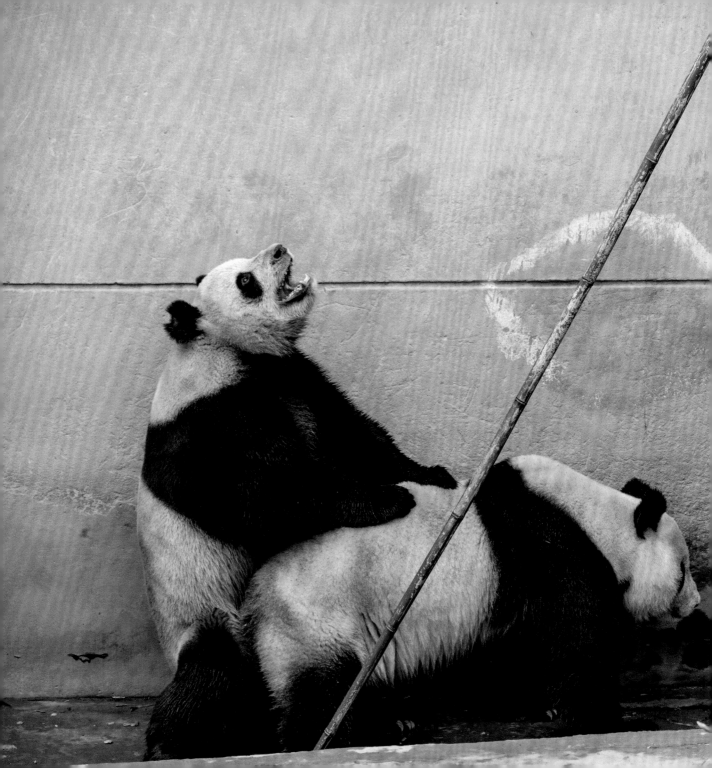

Panda mating happens so infrequently that the act is almost never witnessed by other pandas, leaving them with very little notion of how to go about it. In hopes of cluing them in, scientists went so far as to show the bears 'panda porn' on television sets in the early days.

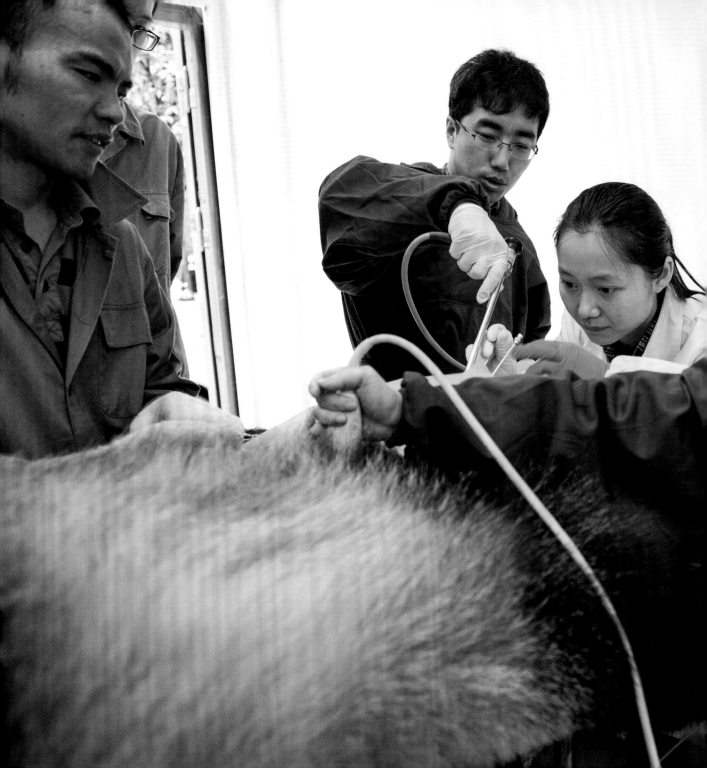

These days, protocol includes artificial insemination, sometimes with sperm from two males. Endocrinologists monitor hormones in the urine that can predict ovulation and may inseminate females several times within a day or two to boost the chances of implantation.

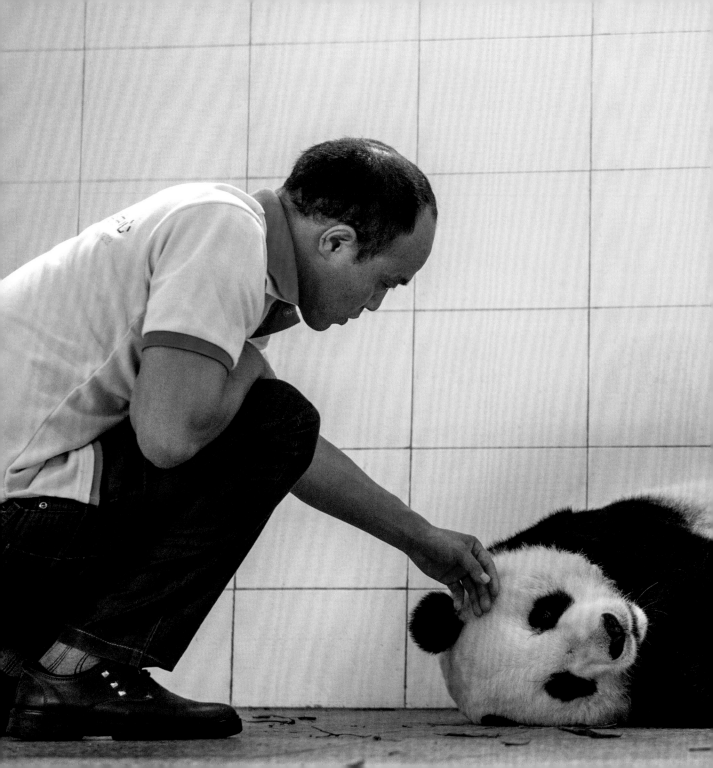

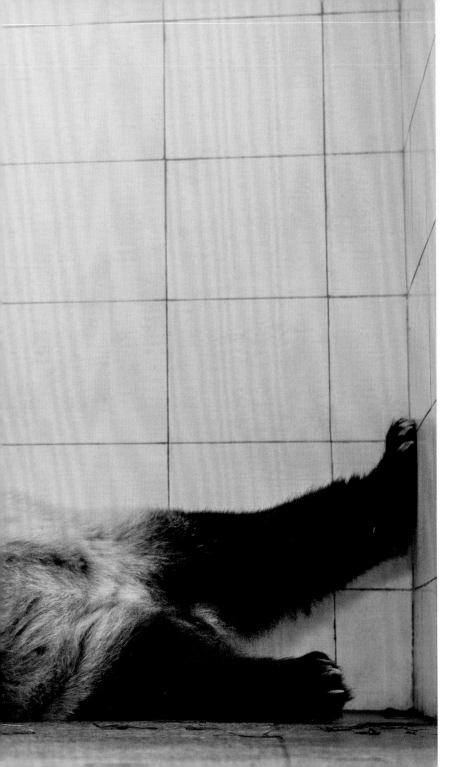

It's hard to tell if a panda is pregnant. The foetus is so tiny that it's easy to miss on an ultrasound. Pandas can have delayed implantation, extremely varied gestation times, random hormone fluctuations and quiet miscarriages.

Blind, nearly hairless, squeaky
and 1/900 the size of its
mother, a newborn panda is
as needy as a baby can be.

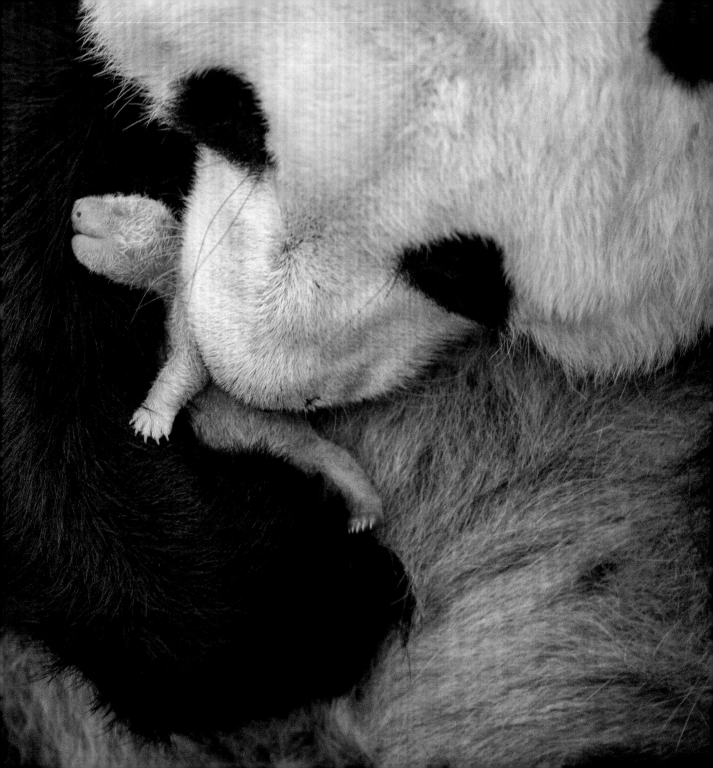

About 50 per cent of giant panda births in captivity produce twins, but most mothers will care for only one infant, so human keepers pitch in and, every few hours (or days as they get older), the keepers replace one cub with the other, giving the tiny pandas a chance to bond with their mother. In the wild it's likely that only one cub would survive.

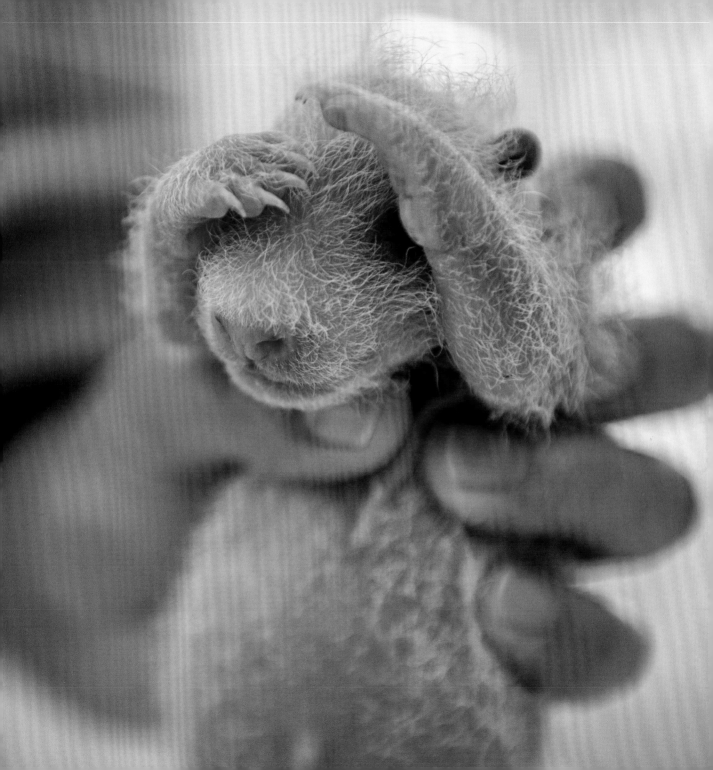

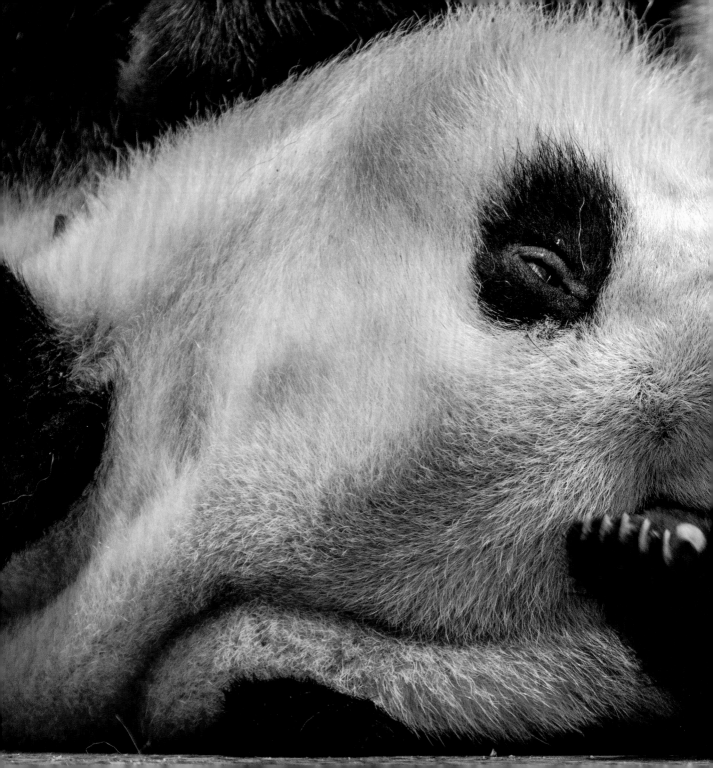

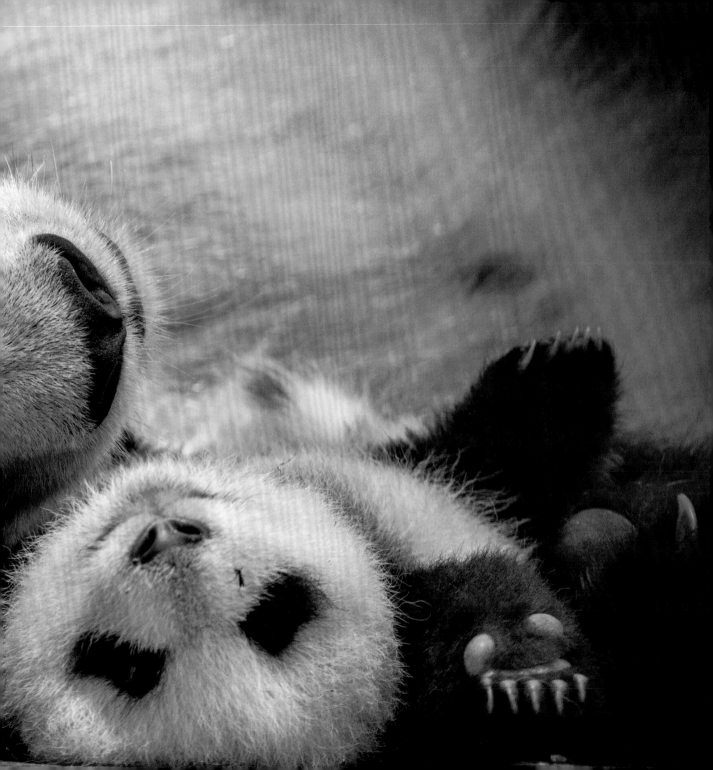

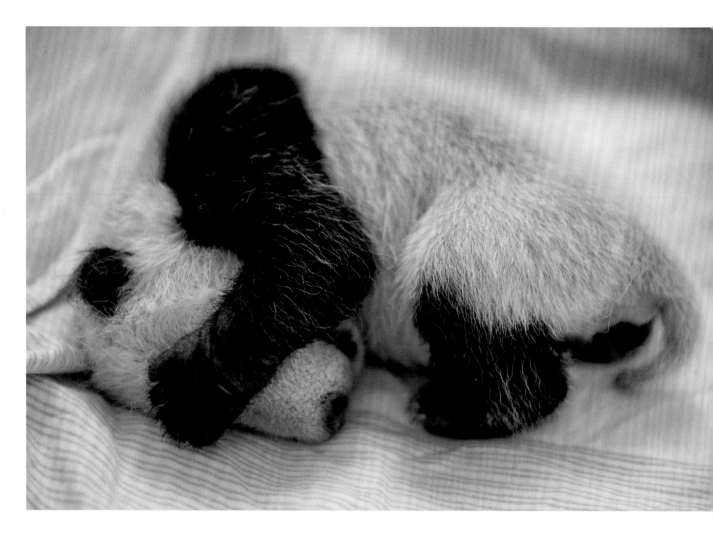

Pandas like to sleep, about 10 hours a day, 2–4 hours at a time. They will camp out anywhere, from the tops of trees to the forest floors and lie on their backs, sides or stomachs when stretching out for some quality zzzs.

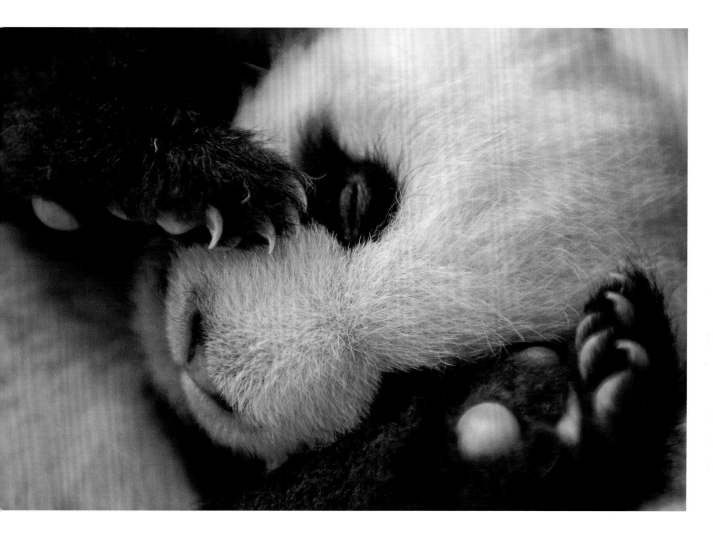

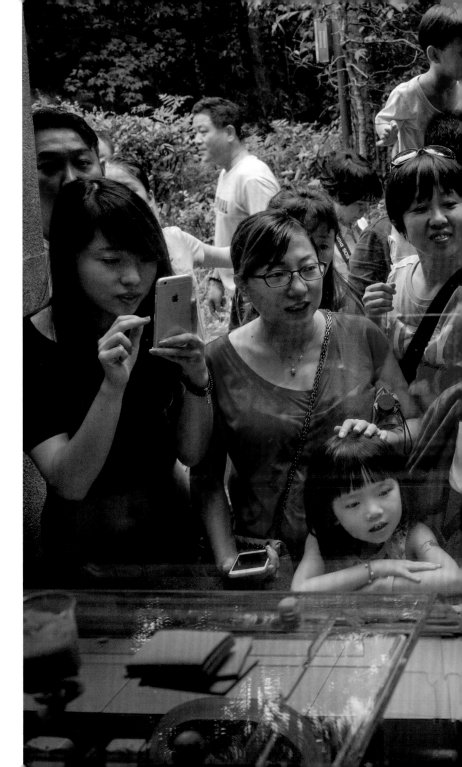

Visitors are so excited about the prospect of seeing the baby pandas that they press their noses and cameras against the incubator room window during tours, ooh-ing and ahh-ing over the fluffballs in baskets on the floor.

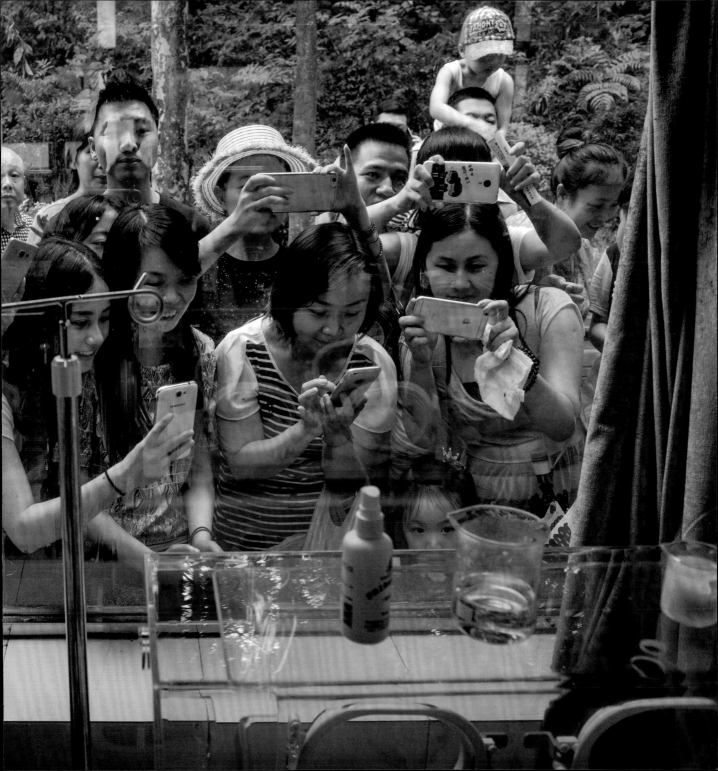

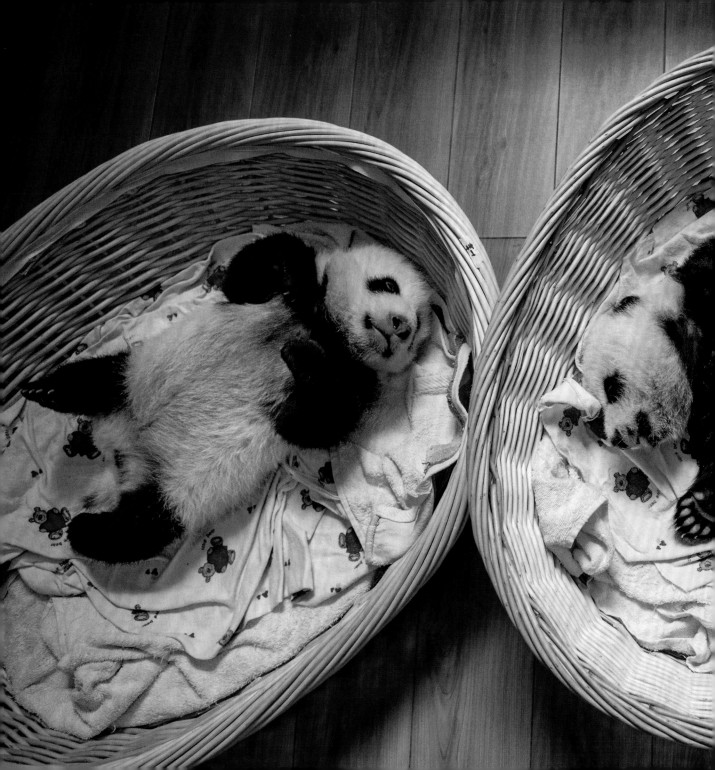

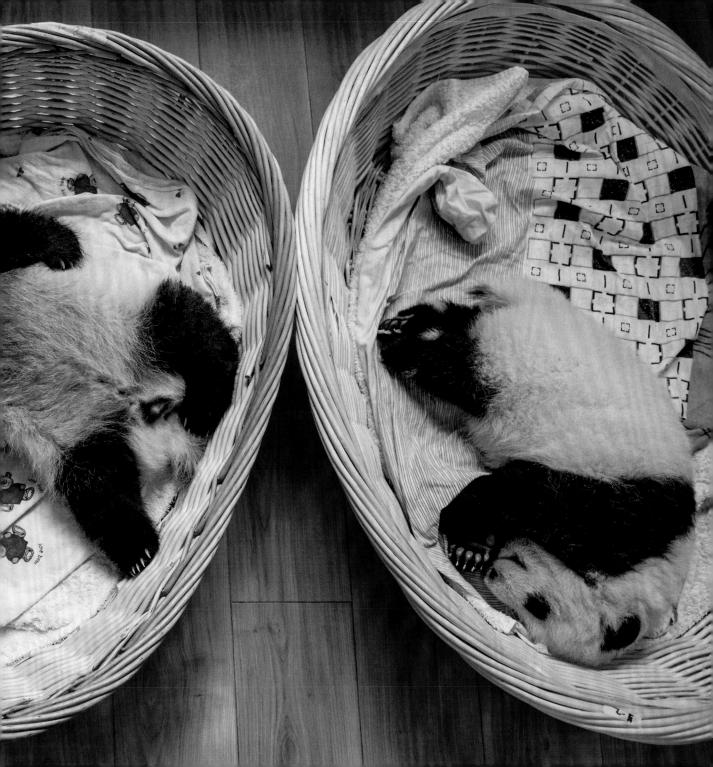

From newborn to three months old, these baby pandas are cared for by specially trained panda nannies. Just like human babies, they need regular feeding and plenty of sleep to prepare their little bodies for growing up.

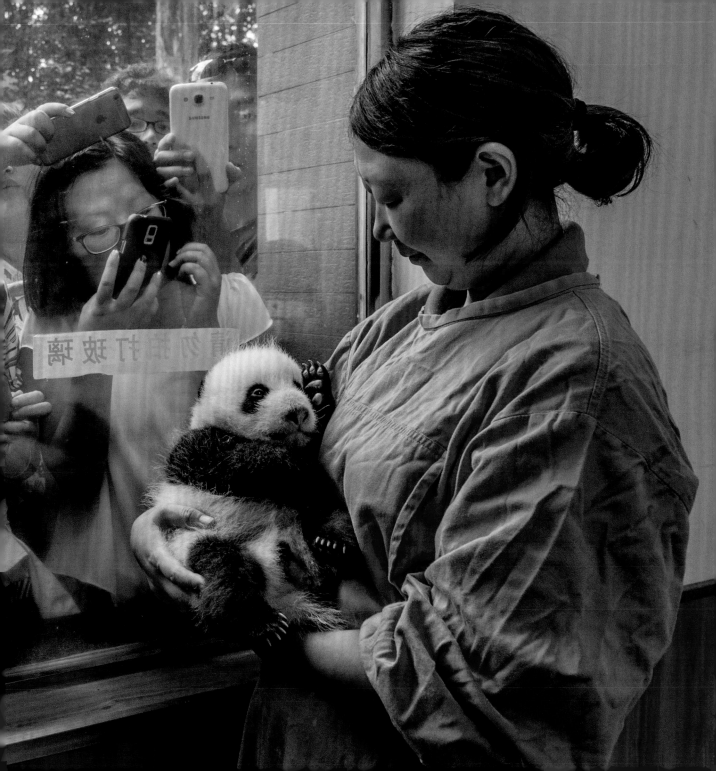

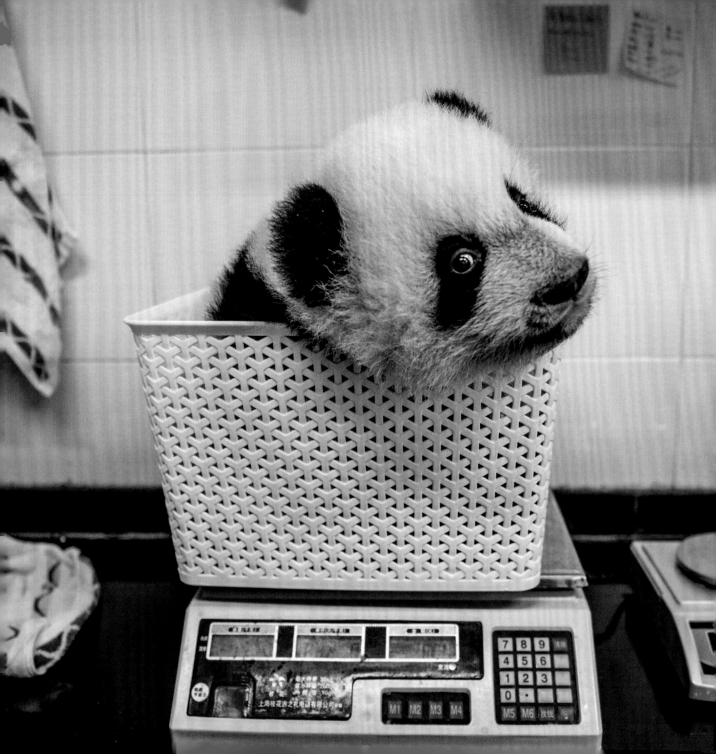

Even pandas have Monday mornings! A day at the 'office' for a newborn giant panda includes being weighed at the Bifengxia Giant Panda Base in Sichuan Province, China. Baby pandas grow quickly – they are among the fastest growing mammals, increasing from around a ¼ lb to 4 lbs in its first month.

In the incubator room at Bifengxia
Giant Panda Base, cub keeper
Liu Juan nuzzles a furry charge.
Despite the pressure of keeping
the babies alive and well, there
are rare moments when the
caretakers get to relax and enjoy
the animals that depend on them.

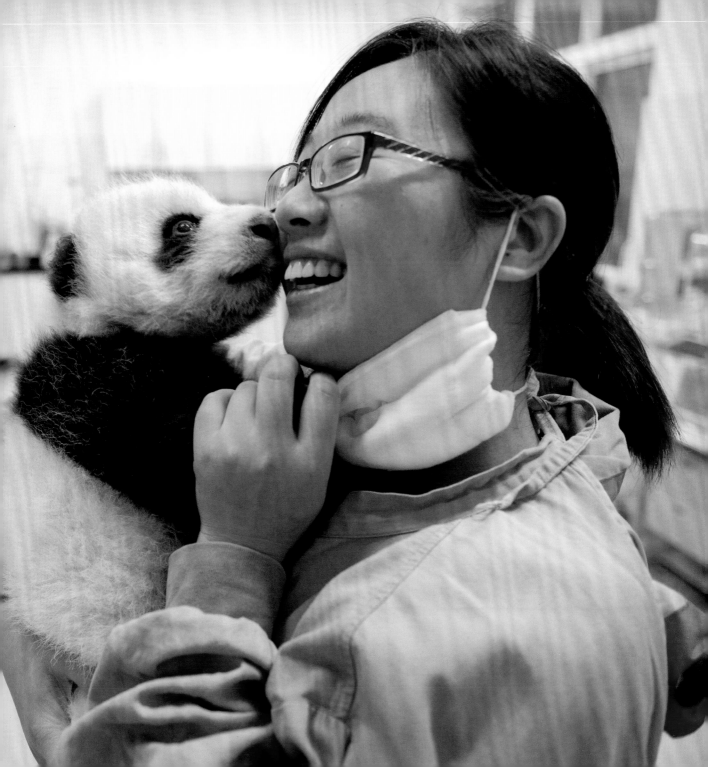

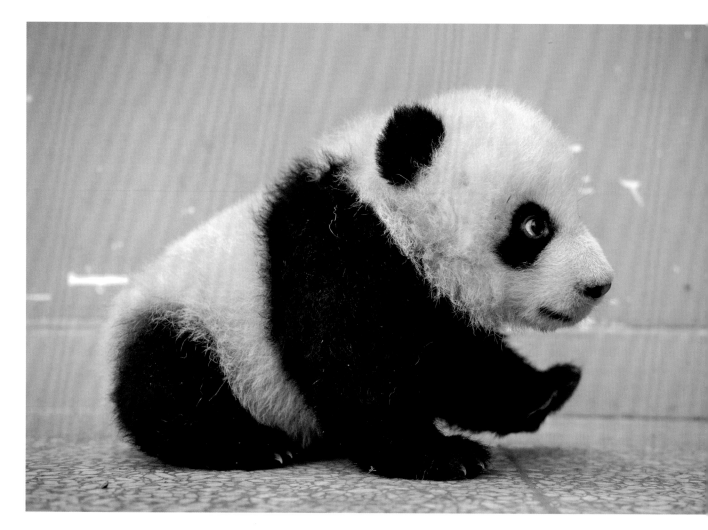

Incubating the newborns,
bottle-feeding, rocking, burping,
responding to their bleats for
attention, rubbing bellies to
stimulate the gut, weighing
and measuring and keeping
the toddlers from wandering
– the work is non-stop.

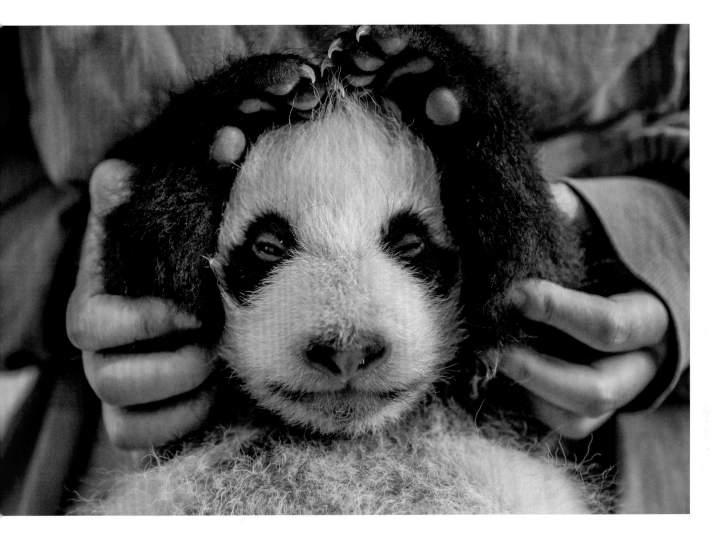

There is massive pressure, Liu Juan says, to keep the cubs alive, 'They are so important to China.'

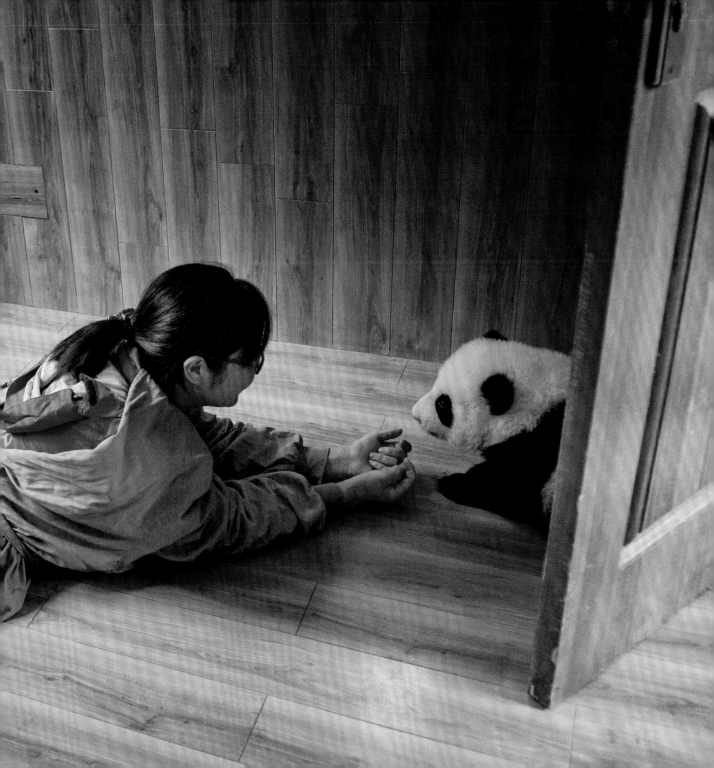

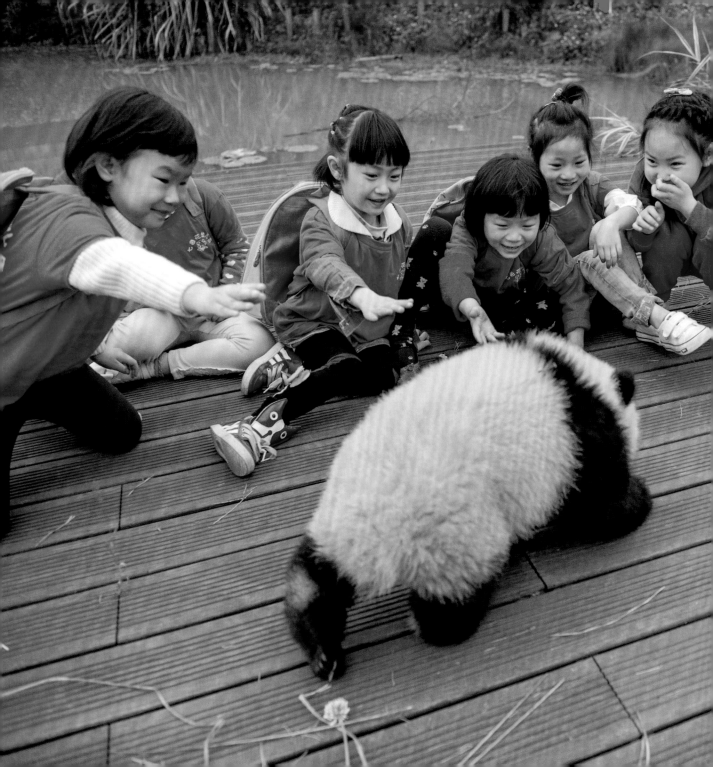

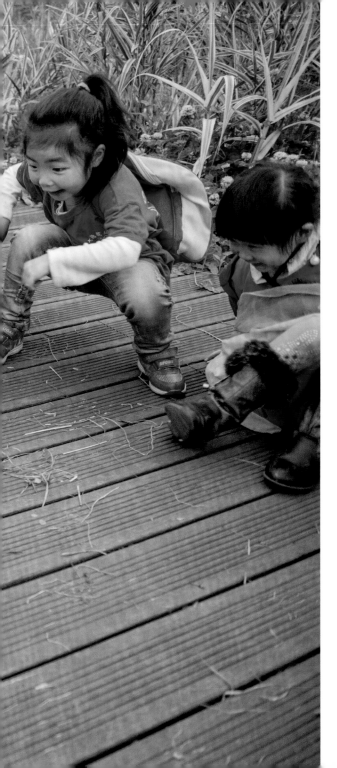

The nation of China saved an animal on the brink of extinction by building an entire community that grew up around pandas. All the residents, from scientists to school children, rallied around saving them. Here, children meet a sixth-month-old panda at the Dujiangyan Panda Center, a part of the China Conservation & Research Center for the Giant Panda (CCRCGP).

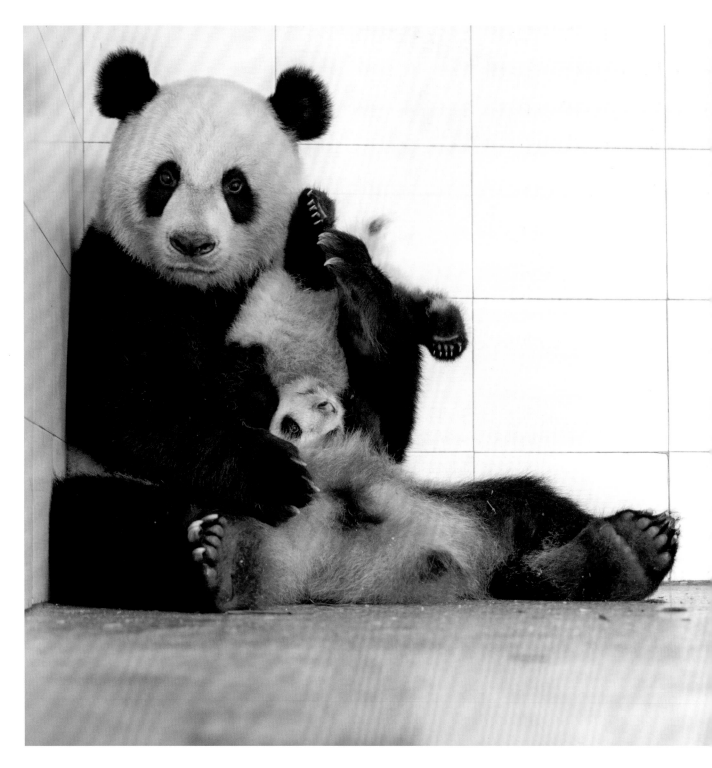

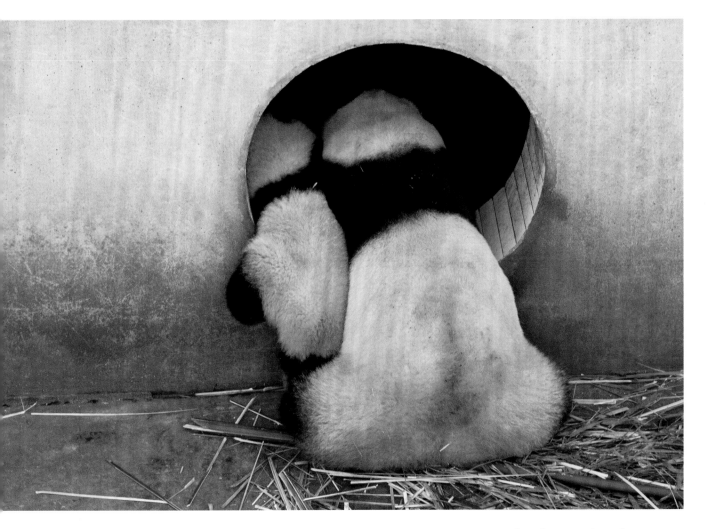

Giant panda cubs snuggle with their mothers at the Bifengxia Giant Panda Base in Sichuan Province, China. Although panda cubs grow quickly, their mothers will cradle them for much of the first year of their lives while they nurse.

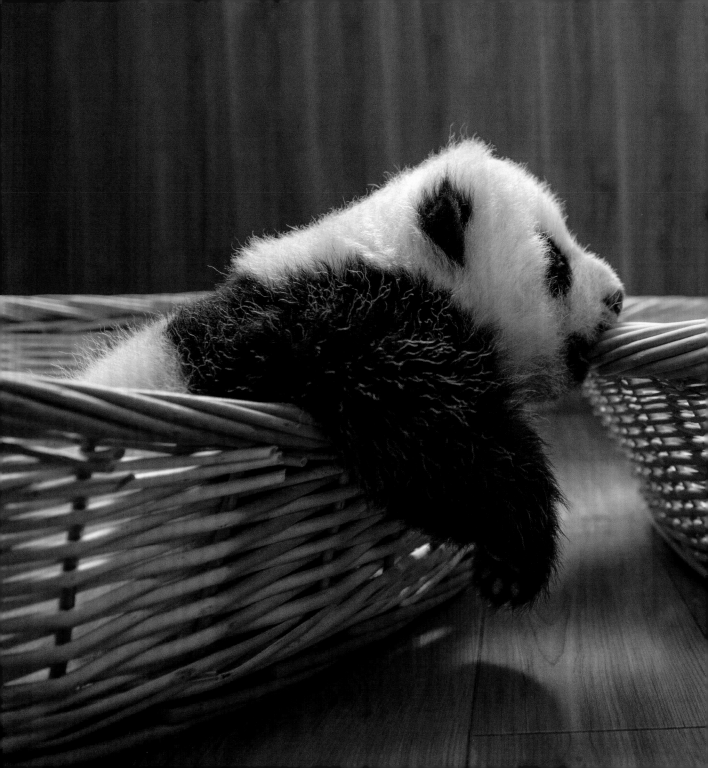

A panda cub tries to escape,
wide-eyed and wiggly, squeaking
and smelling like a wet puppy dog.

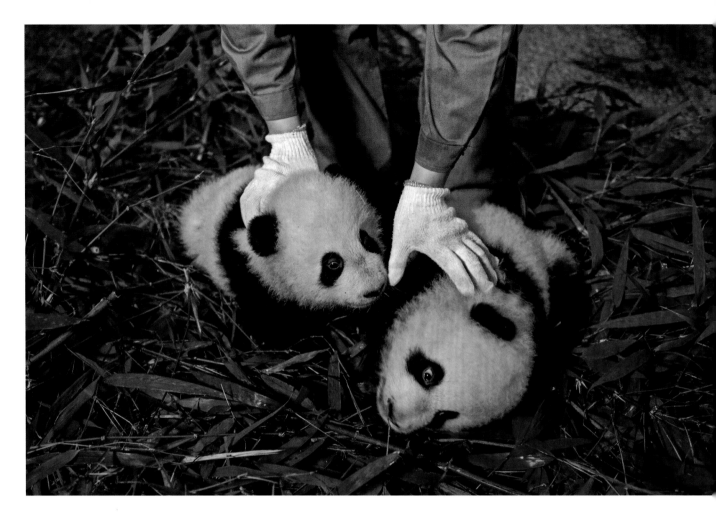

'Even after many years, whenever a panda is pregnant or gives birth here, everyone is so joyful and excited,' says keeper Zhang Xin. 'We look every day at the adults, the babies, how much they are eating, what their poo looks like, if their spirit is good. We just want them to be healthy.'

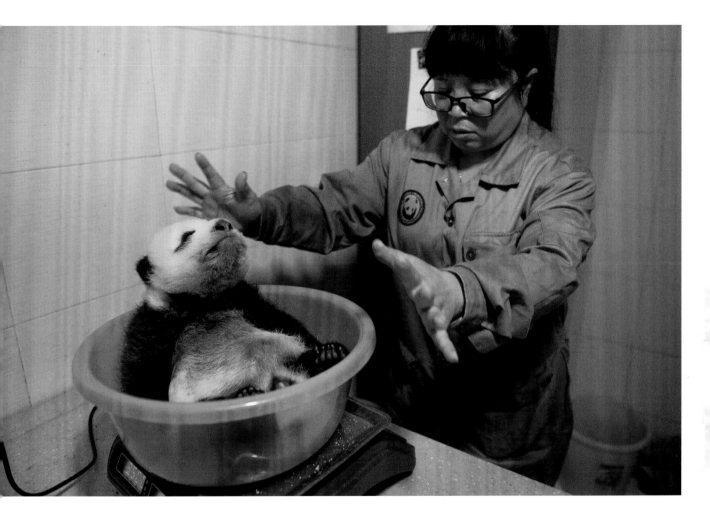

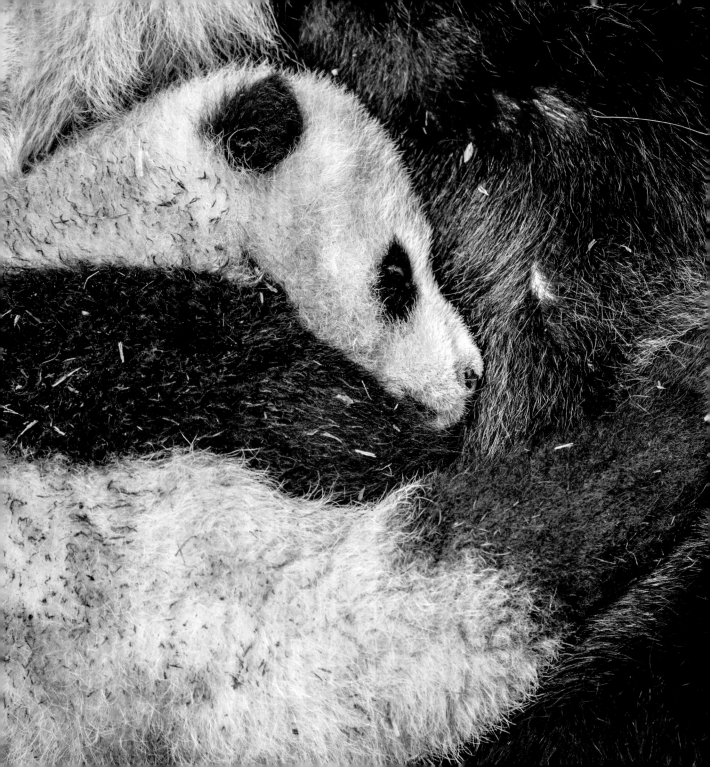

There were three problems related to breeding pandas in captivity. Firstly, it was hard to get pandas to mate. Secondly, it was a real struggle to get pandas pregnant. Finally, it was extremely difficult to keep the babies alive. But, after decades of work, the scientists are on their way to saving an icon.

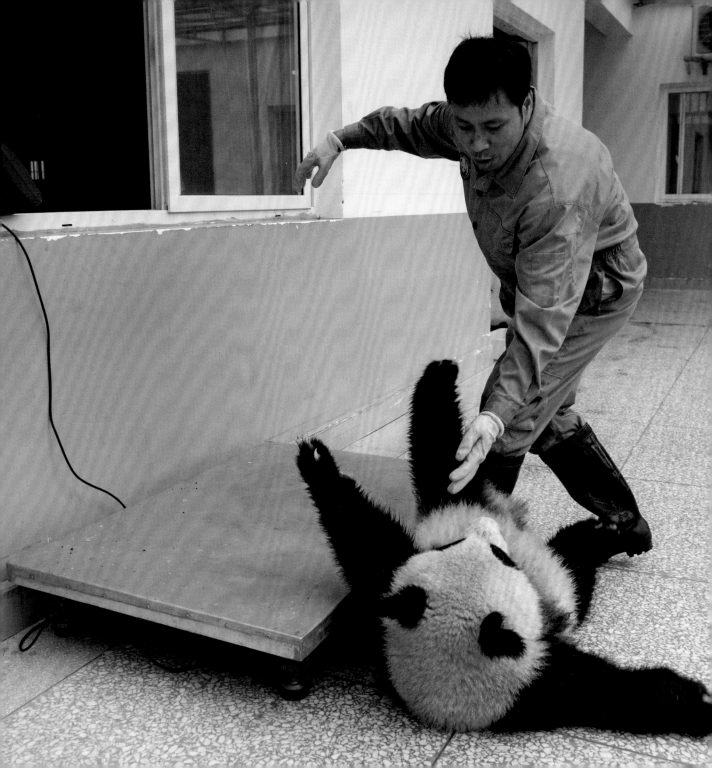

A cub falls off the scale after being weighed at the Bifengxia Giant Panda Base in Sichuan Province, China. In the wild, once they've grown to adulthood, female pandas may weigh up to 15.5 st (220 lbs) and males up to 17.8 st (250 lbs), and they'll range from 48–72 in (4–6 ft) long.

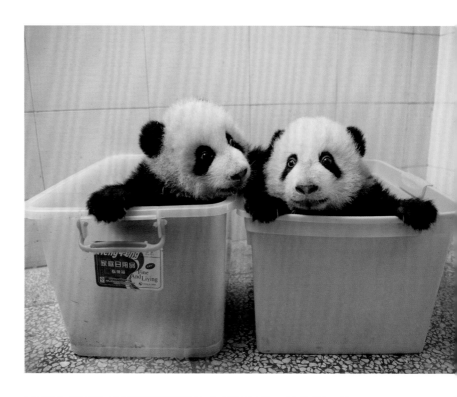

Bifengxia Giant Panda Base in Sichuan Province, China, is at the forefront of panda conservation. It is a specialist breeding centre and maternity ward for giant pandas. There are wall-to-wall pandas here. With so few left in the wild, each panda has an important role to play.

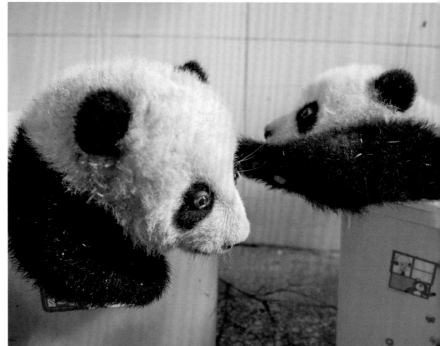

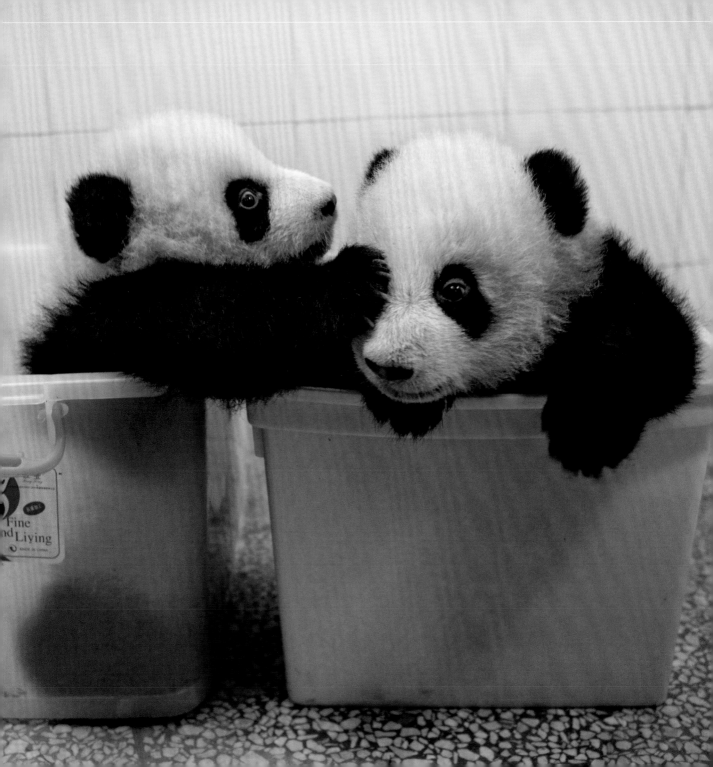

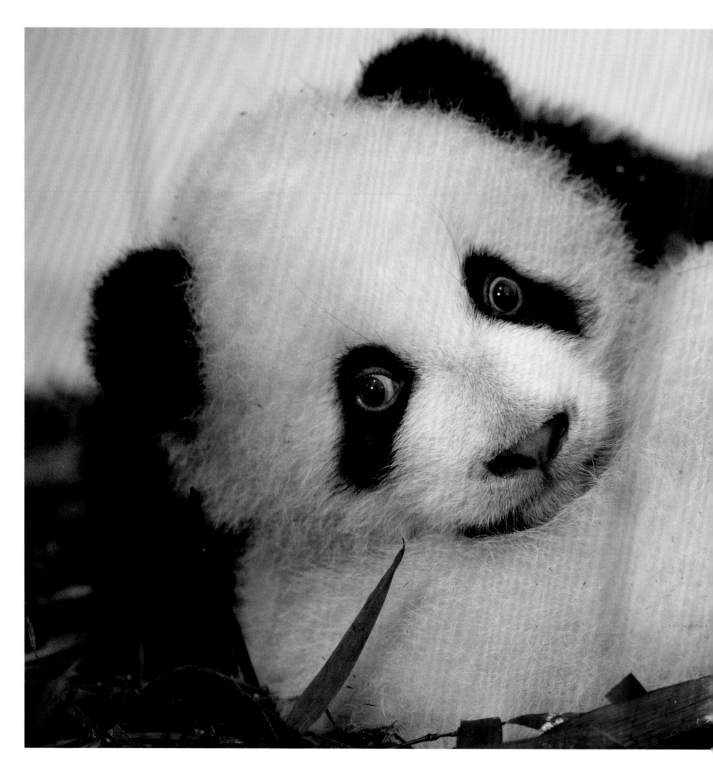

Baby pandas have developed a fairly effective warning system to help their mothers know their location and avoid sitting on them – squeak for your life! A baby panda will regularly emit a piercing sound for several days or weeks after birth.

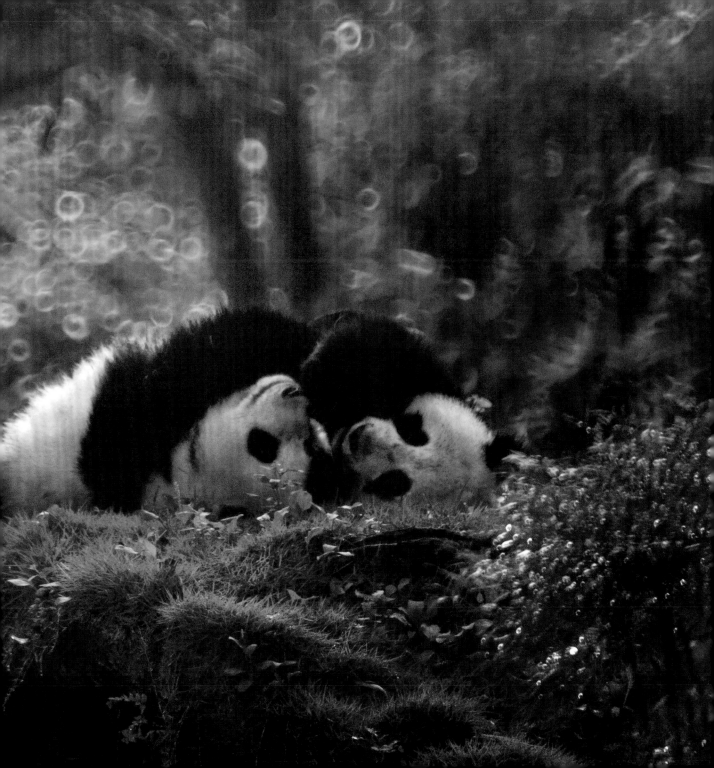

Pandas are not social animals and do not live together in the wild. They are solitary creatures, who only meet during the breeding season. Panda cubs will emerge from the nest at about three months of age and only stay with their mother until the next breeding season starts.

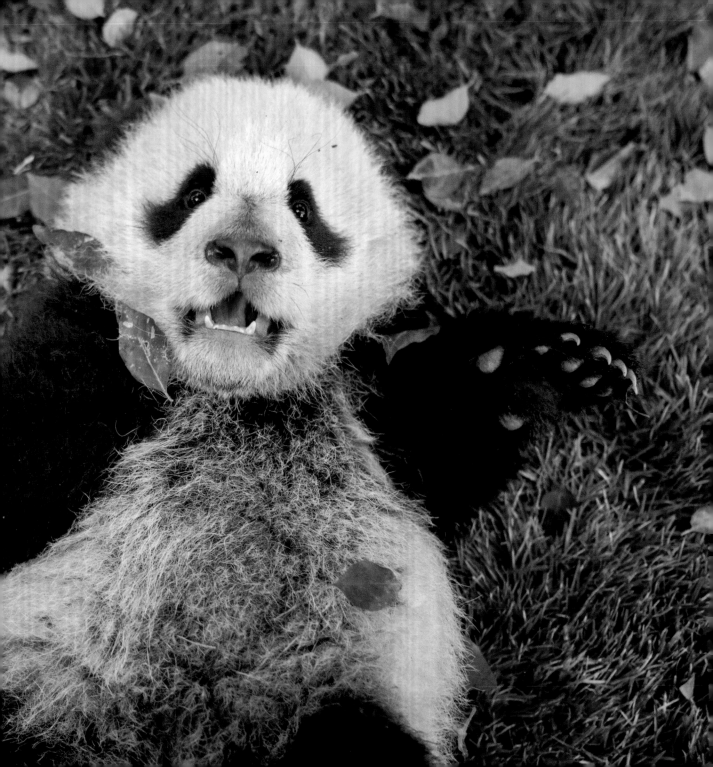

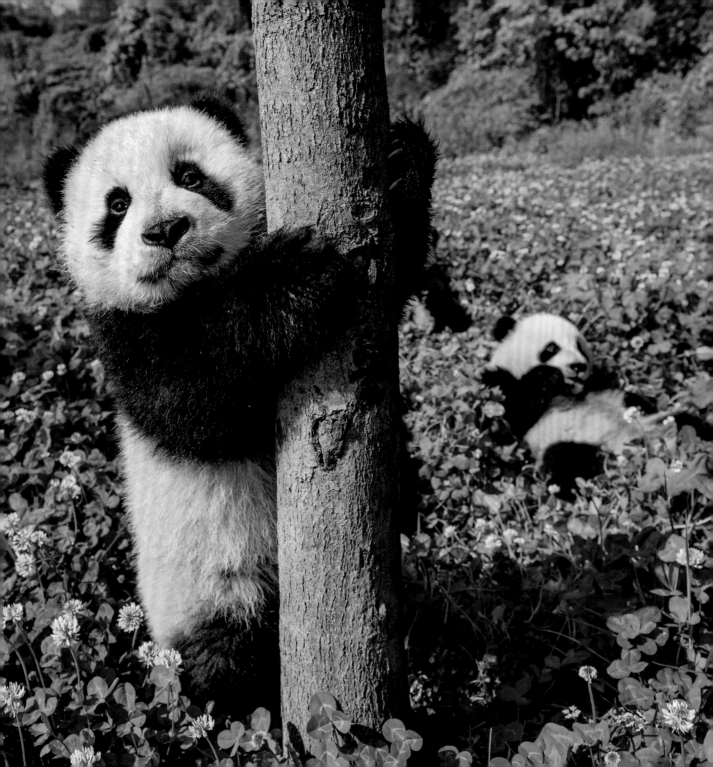

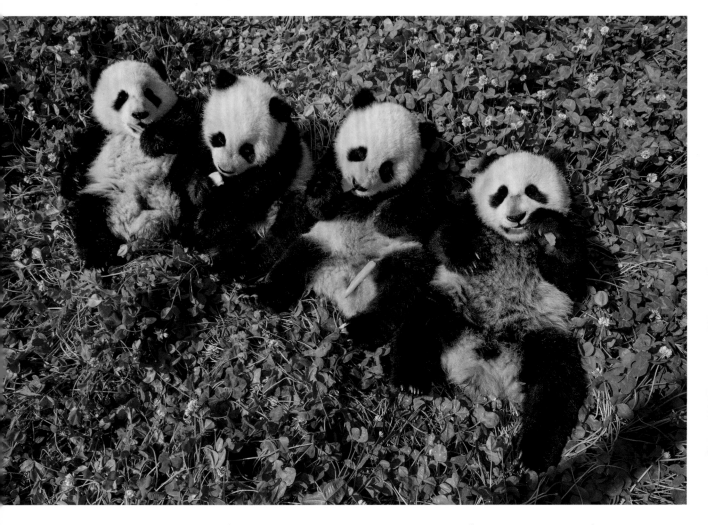

This is Dujiangyan Panda Center, a rescue and rehabilitation centre for pandas. Here, making friends and building relationships is key to learning life skills. At one year old, babies are brought here to buddy up. In the wild, giant pandas prefer to live alone.

Baby pandas Sen Sen and Xin Xin play in a tree at the Gengda Giant Panda Base, within the Wolong Nature Reserve and China Conservation and Research Center for the Giant Panda (CCRCGP). With their mothers kept busy eating 13–16 hours a day, panda cubs avoid predators by heading to the safest place they can find – the tops of trees.

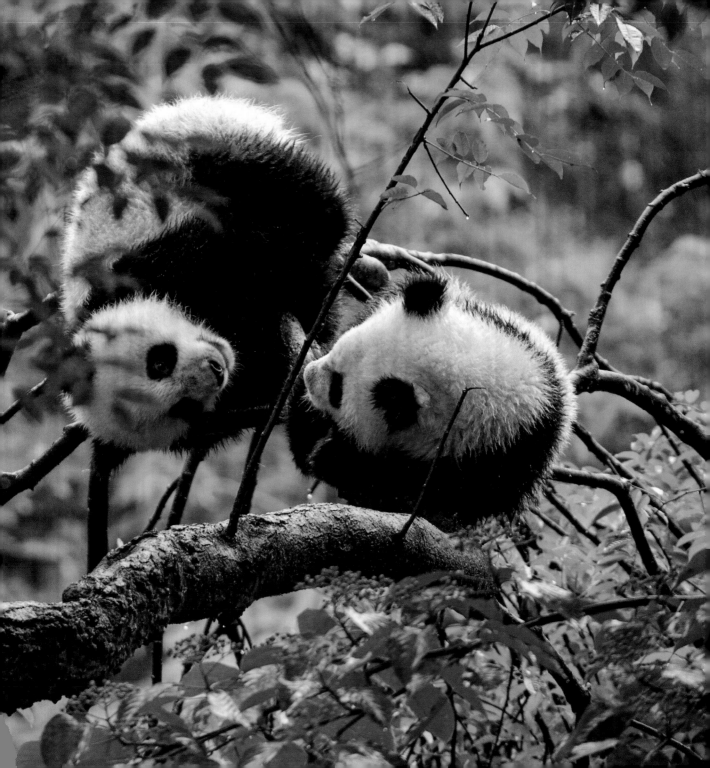

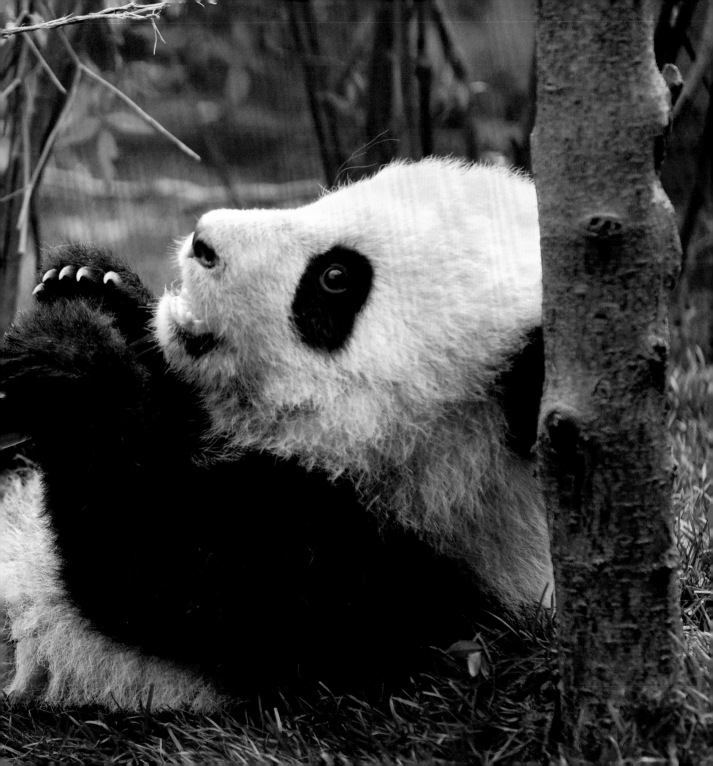

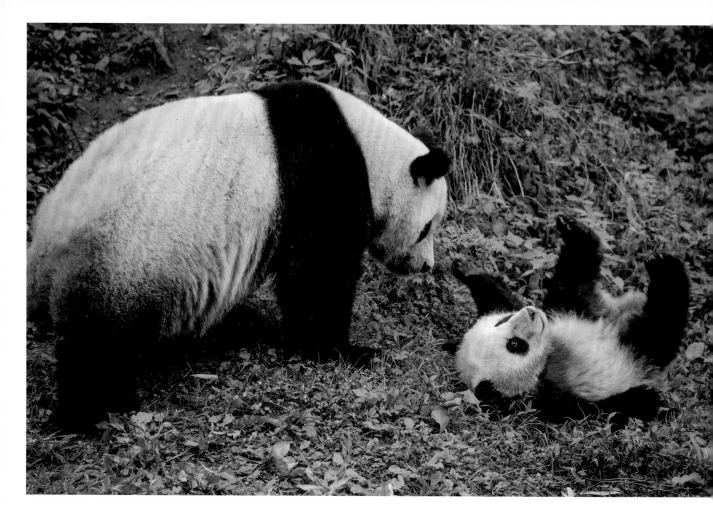

Giant panda cubs will play hard
with their mothers, climbing trees,
rolling down hills and looking for
ways to entertain themselves.

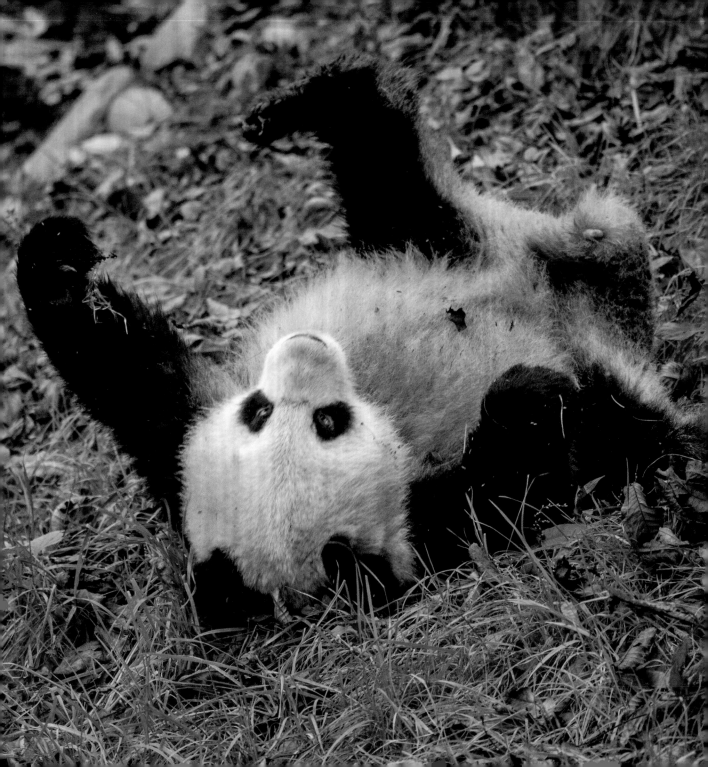

In China, one of the world's best-loved and enchanting creatures is fighting to survive. With fewer than 2000 giant pandas left in the wild, the race is on to increase their population.

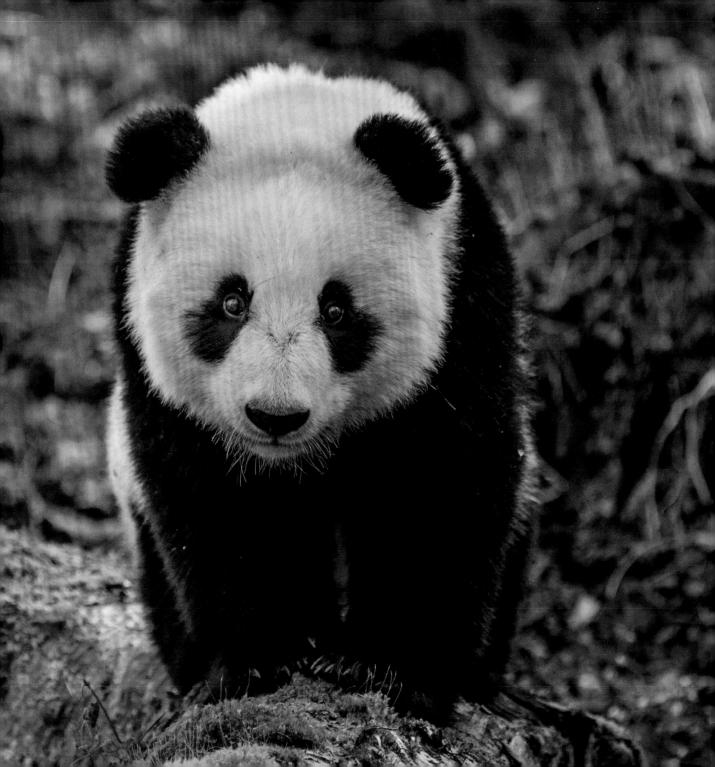

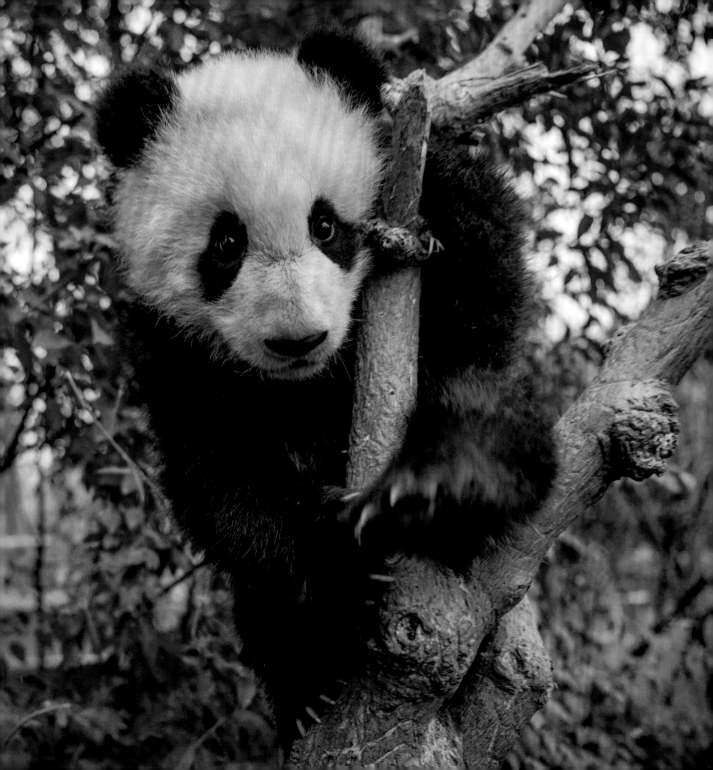

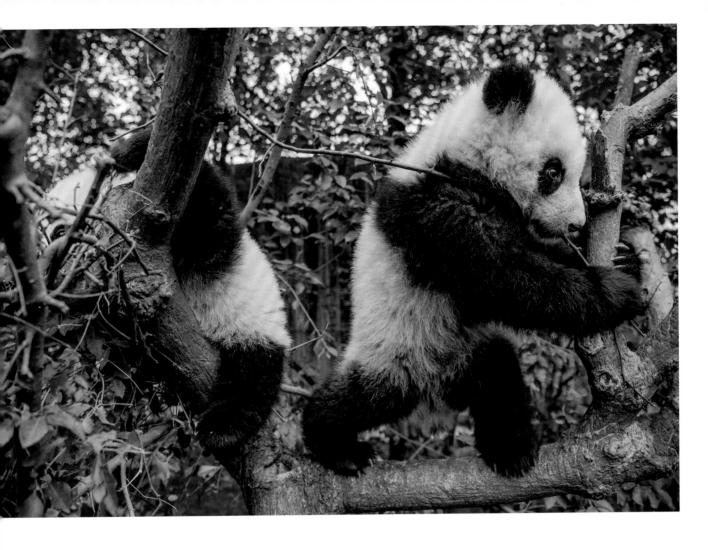

A pair of panda cubs practise climbing in and out of trees. In the wild, they climb to escape predators and find safe places to sleep.

Giant pandas are strong climbers and have also been spotted taking the occasional nap precariously balanced in a tree! Pandas spend the majority of their day eating, but for the remainder of the time they are usually resting or sleeping.

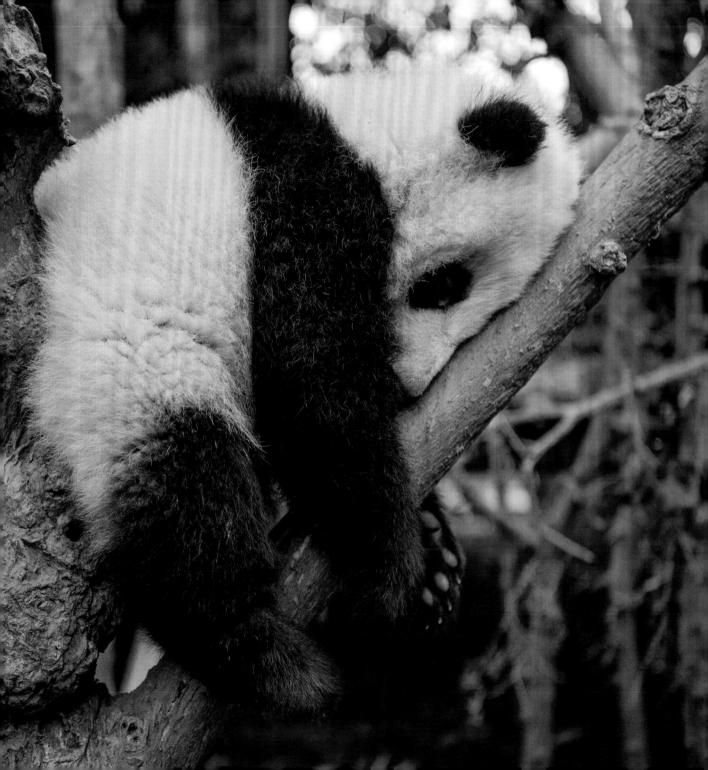

Pandas don't roar like other bears, but they do bleat, like goats, or honk, growl and bark to communicate.

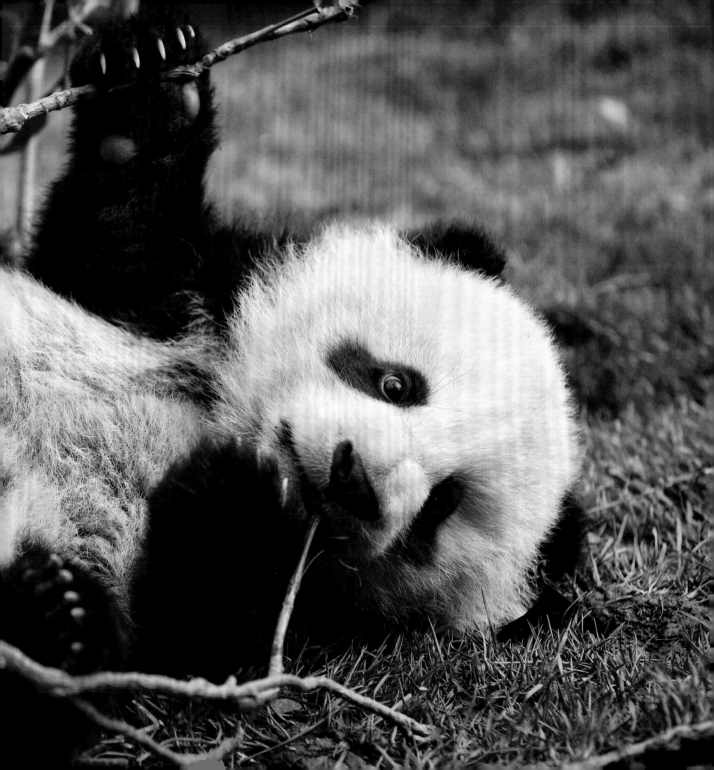

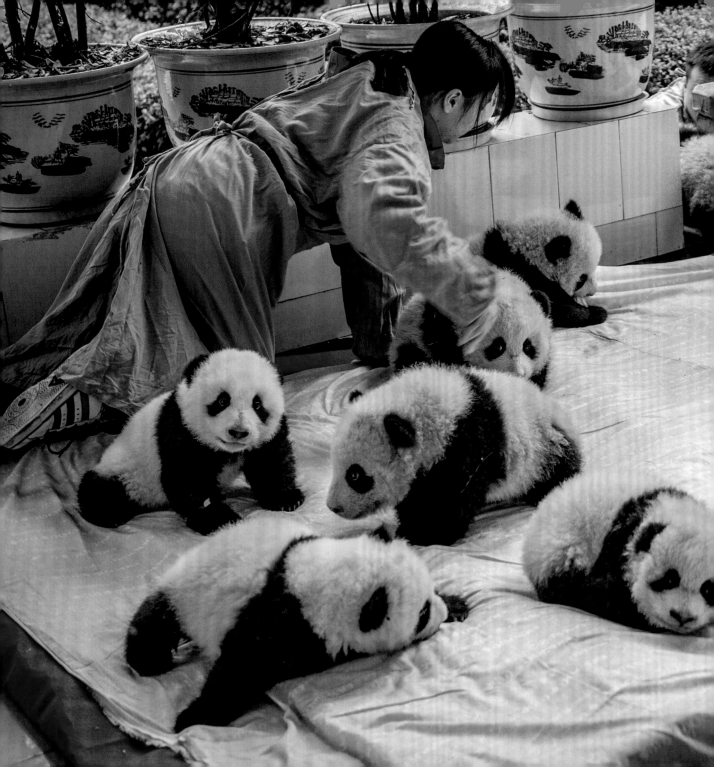

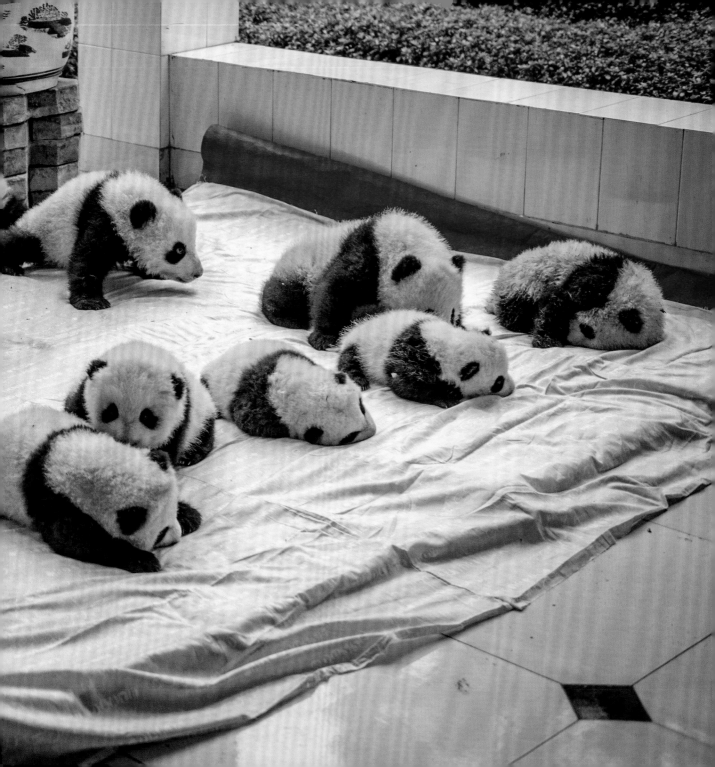

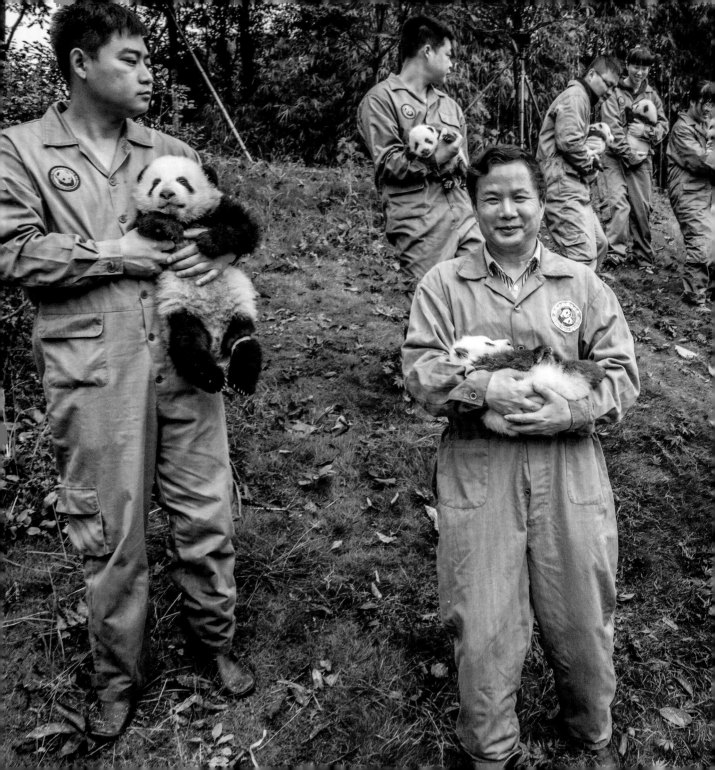

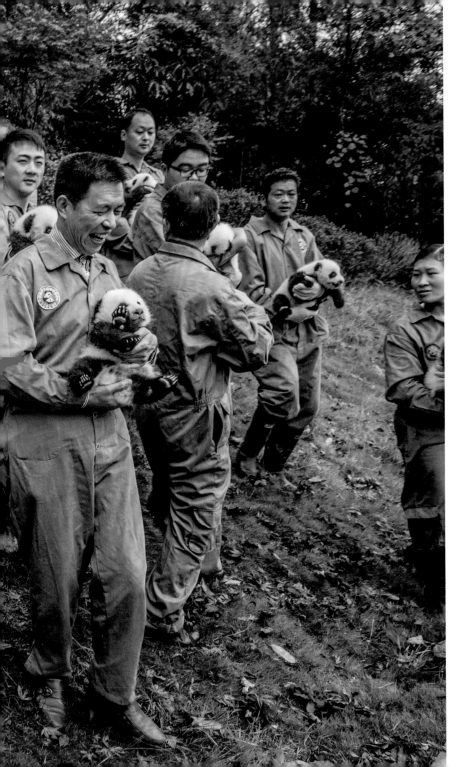

The director of the panda programme, Zhang Hemin – 'Papa Panda' to his staff – poses with cubs every year. Here, he is accompanied by the workers at the Bifengxia Giant Panda Base in Sichuan Province, China.

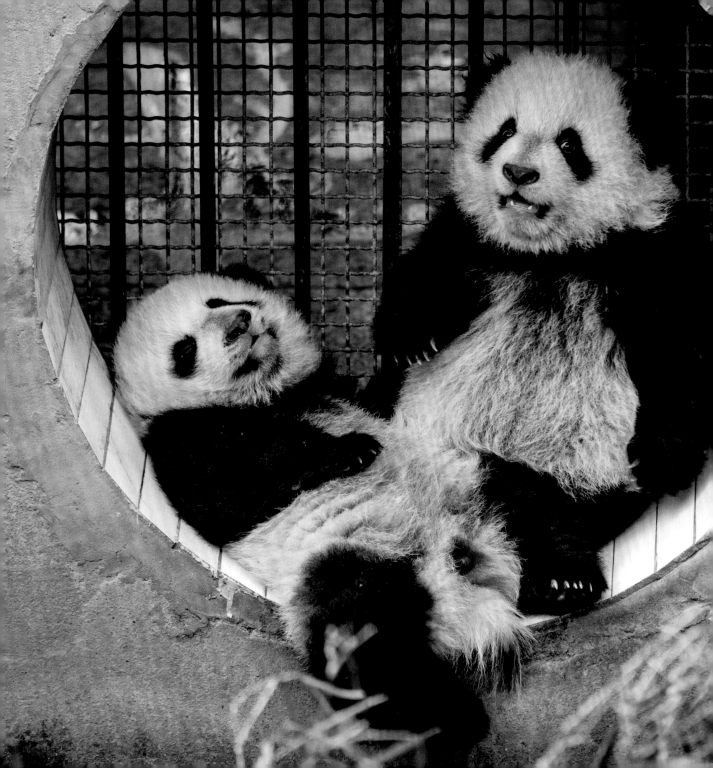

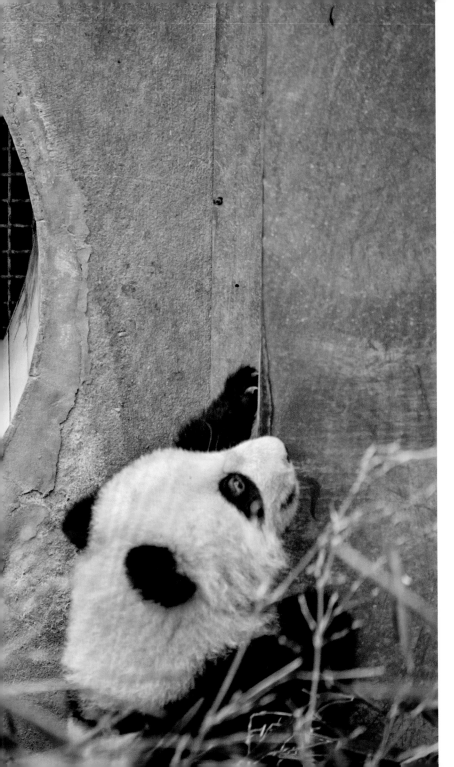

Triple the cuteness – and the work. One mum cares for all these cubs, only one of which she bore. Transferring a weak or rejected infant from its birth mother to a surrogate is just one of the ways the staff are helping to boost cub survival at panda breeding centres.

The nation of China's efforts in panda conservation have filled centres with hundreds of valuable lives. And they're learning how to put these pandas back into the wild landscape... giving hope to an entire species. After one generation in captivity, pandas forget how to be wild and have to be *trained* to be *wild*. Pandas forget how to find good bamboo, how to stay healthy and get leeches off. They don't even know to run from predators. To combat this, the centres have created a series of tests that the cubs must pass through before they can be released into larger enclosures.

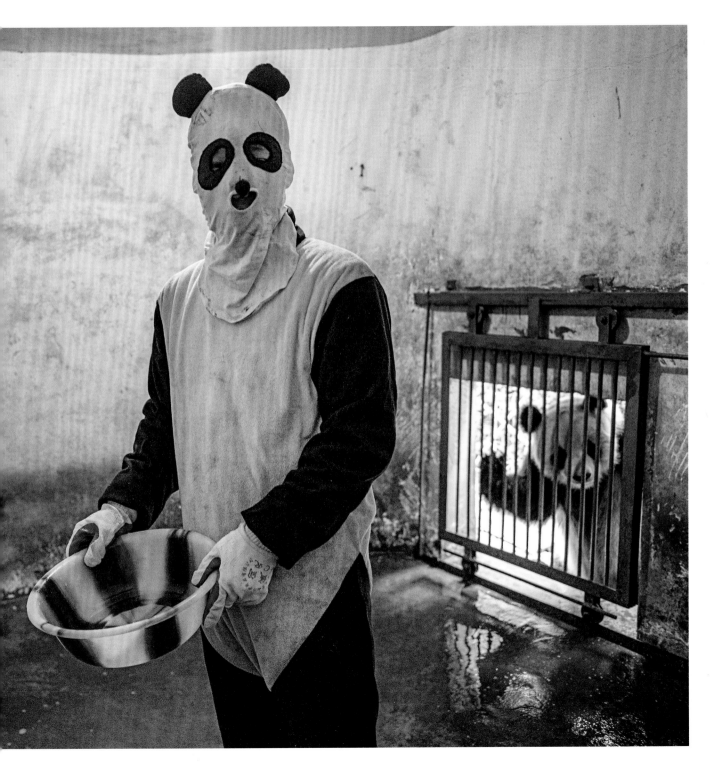

周李秋　　　　　　　　徐建宁

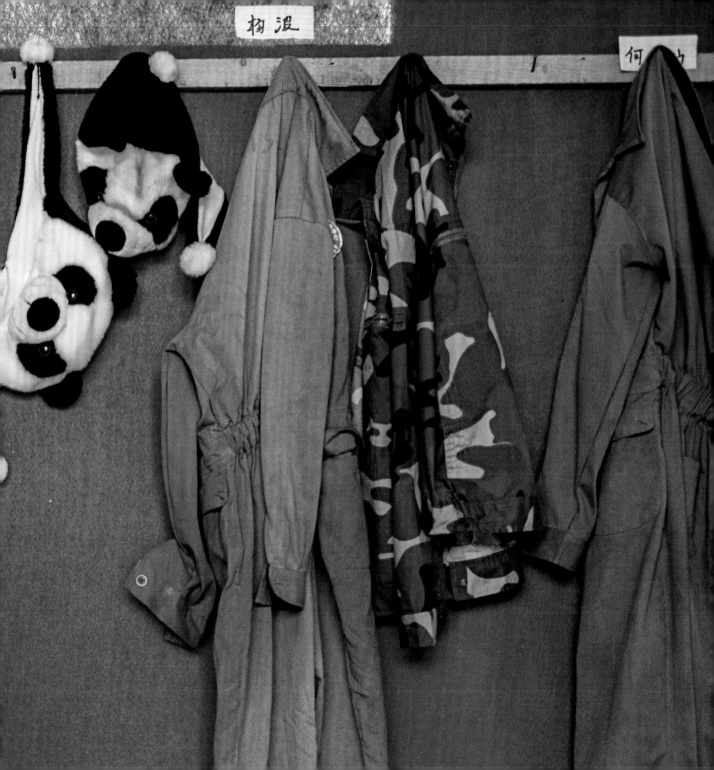

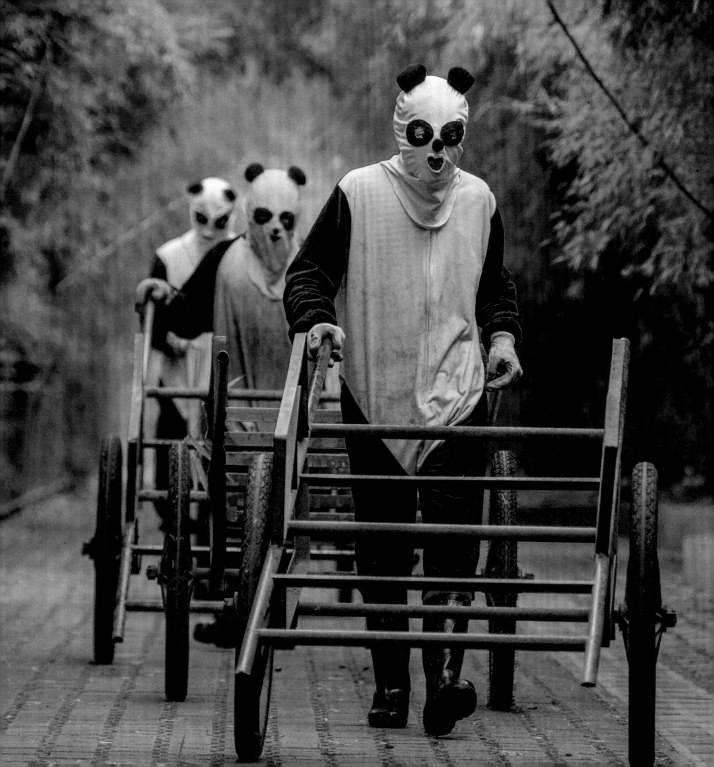

To mask human scents, the researchers and keepers spray panda urine and faeces on their costumes. The disguise helps pandas retain their wildness, preventing them from growing comfortable with humans.

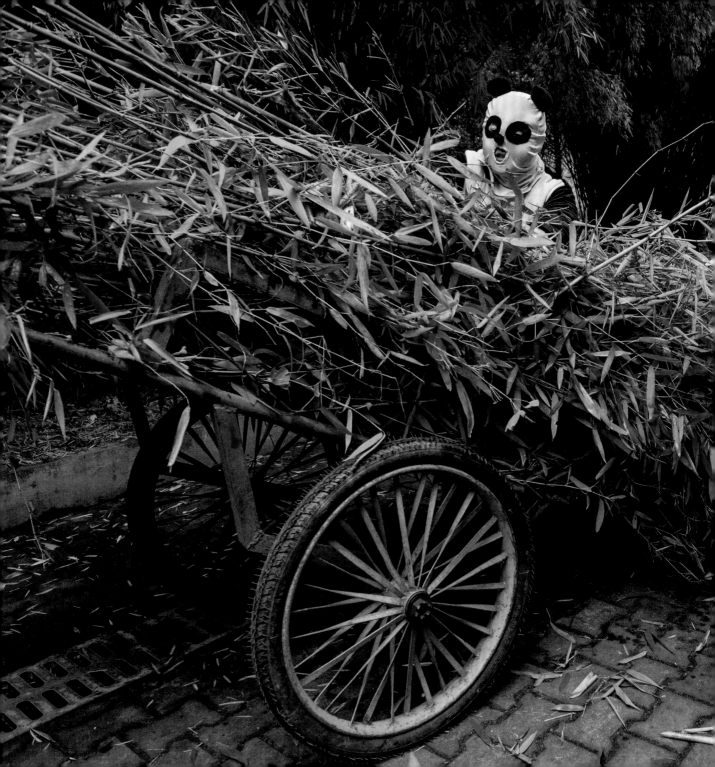

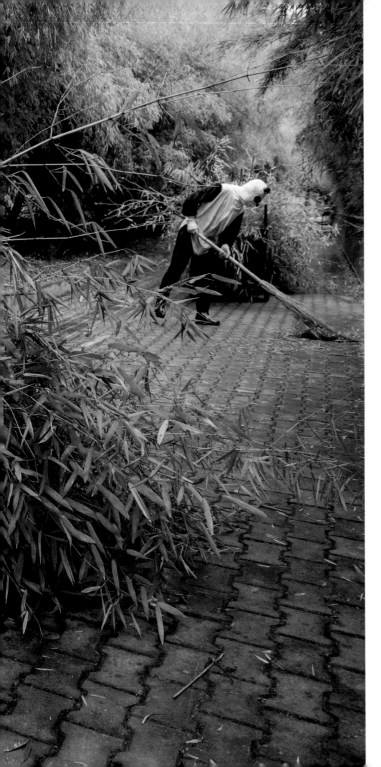

'Papa Panda' says, 'The ultimate goal is to release, release, release. I've had two important jobs in my life so far. To get pandas breeding, which is now no problem. Now, we have to make sure there's good habitat and then put pandas in it.'

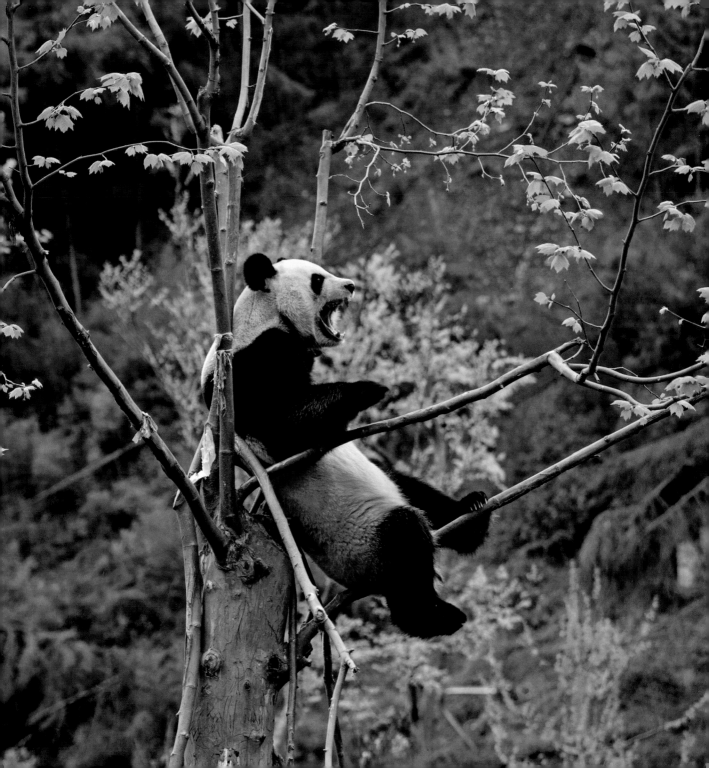

On a positive note, poaching isn't a problem for this precious population – nobody is touching pandas. Hunting them was legal in China until the 1960s; now killing one could result in a 20-year prison sentence.

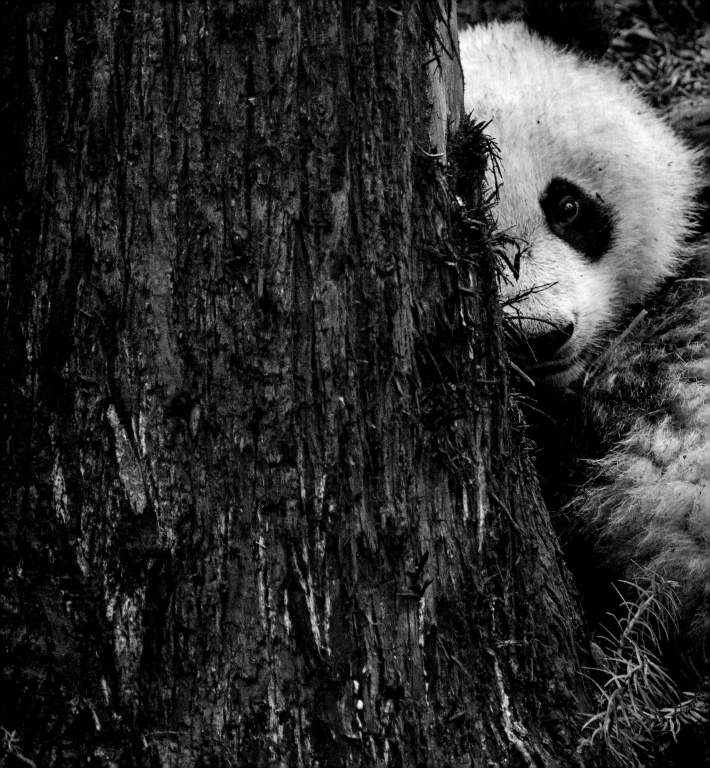

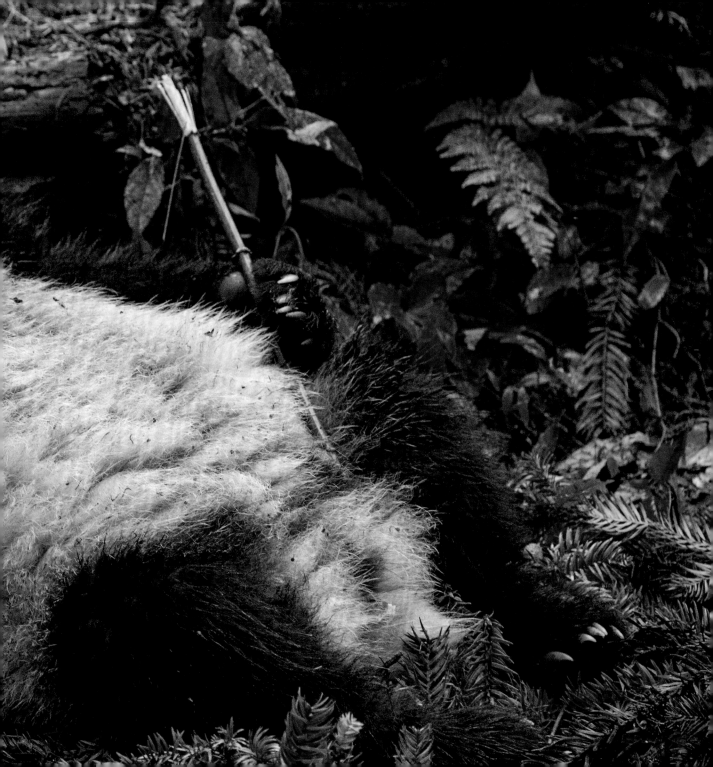

'We will train them to recognise enemies, predators, sounds, friends and environments', says 'Papa Panda'.

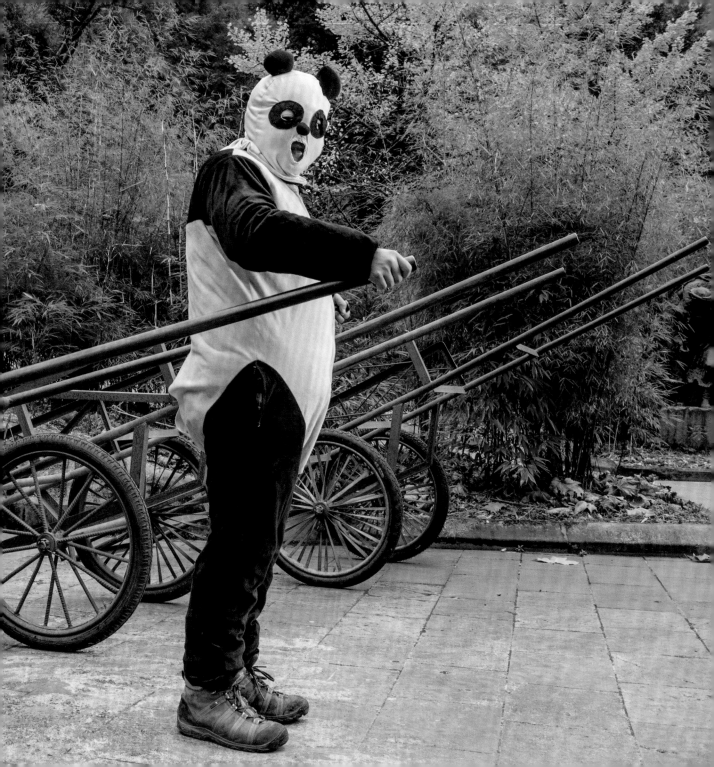

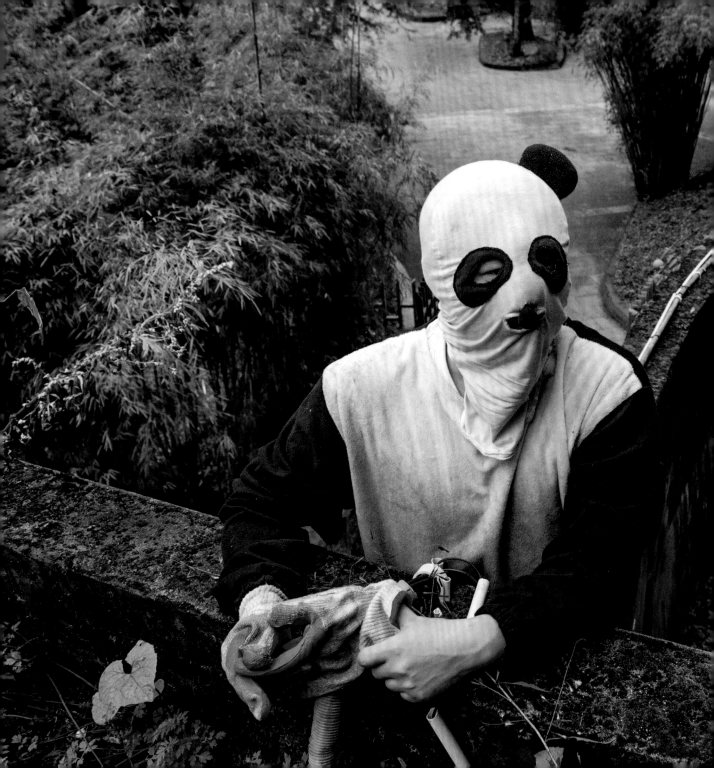

Babies are born in a quiet moss and bamboo haven; the mothers are fed from afar and monitored by keepers hiding behind a wall or watching them on a close-circuit television. As the babies mature they are moved to progressively bigger, more complex and 'wilder' enclosures, where they eventually learn to climb and forage for themselves.

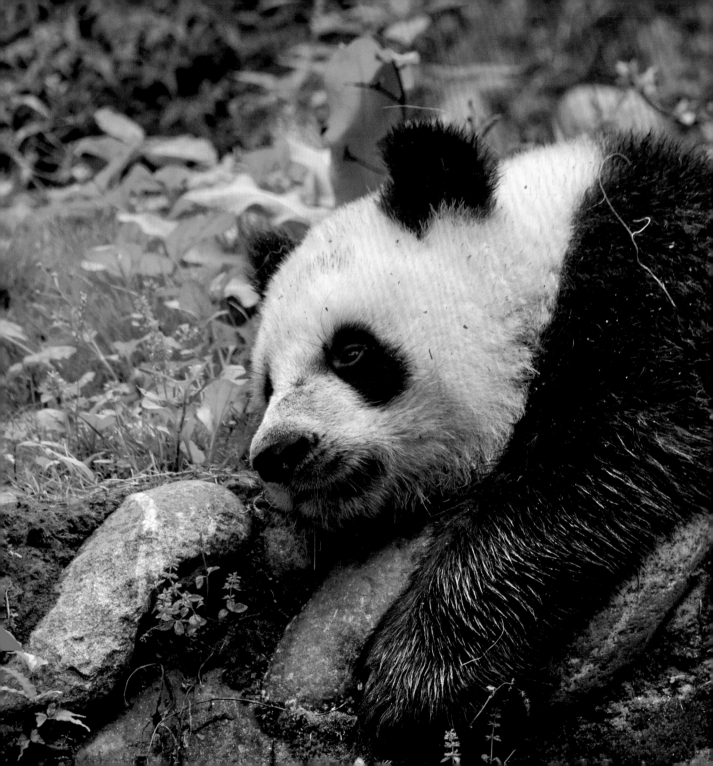

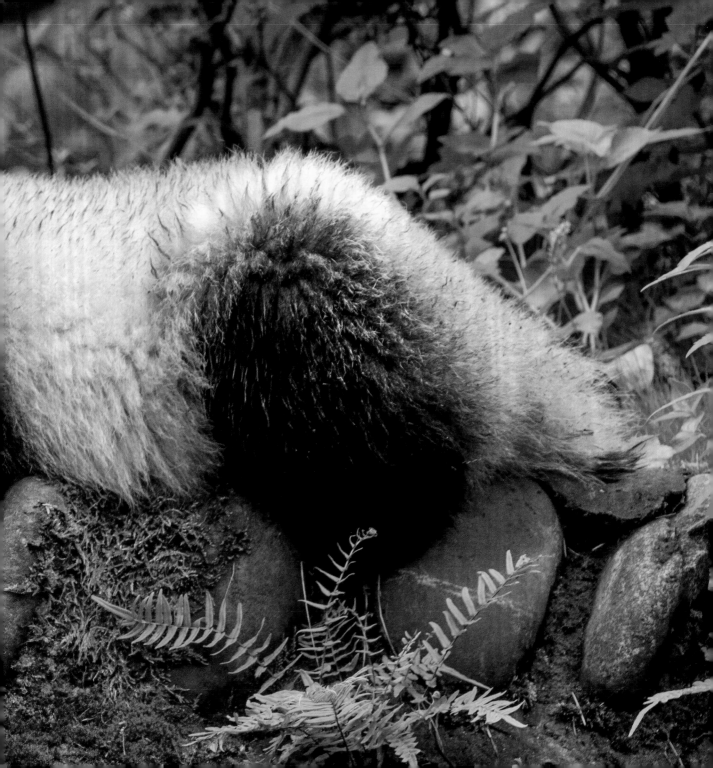

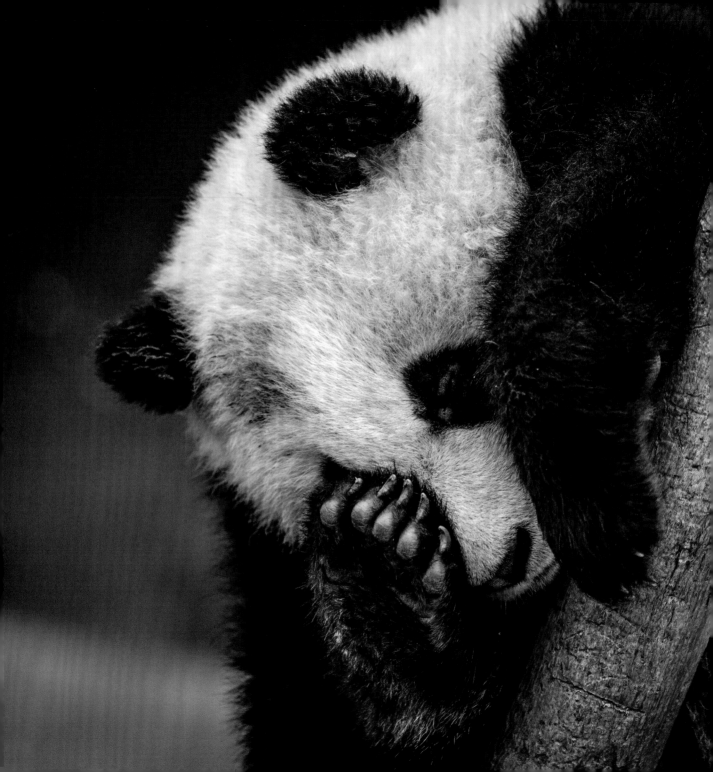

Scientific models warn that in the next 70 years, global warming could reduce the remaining giant panda habitat by nearly 60 per cent. At least for now, rebuilding, connecting, and protecting their habitat may be the best focus for panda conservation.

Gao Xiao Wen poses with the stuffed leopard that Wolong Nature Reserve keepers use to train young pandas to fear their biggest wild foe. A cub's reactions to the 'predator' and its recorded growls help determine if the bear is prepared to survive on its own.

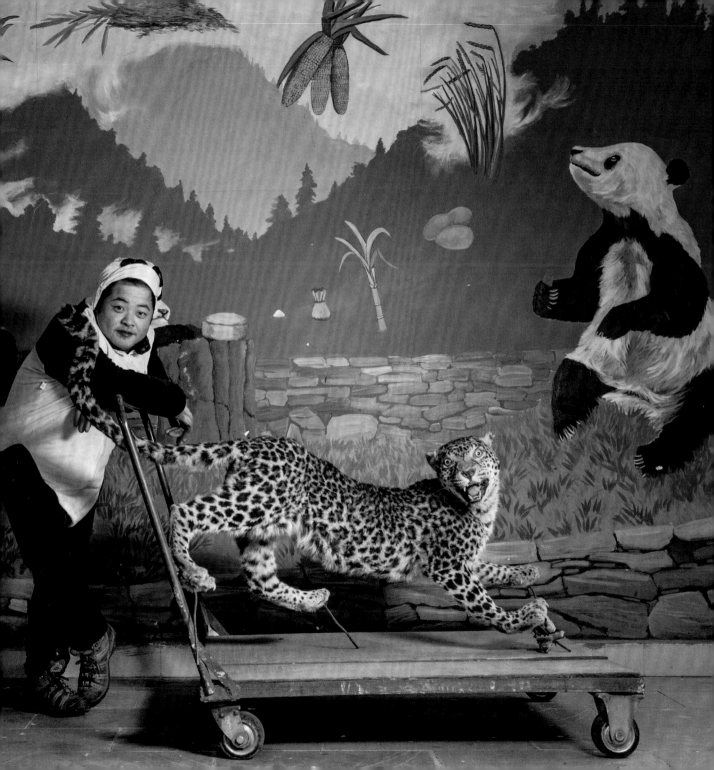

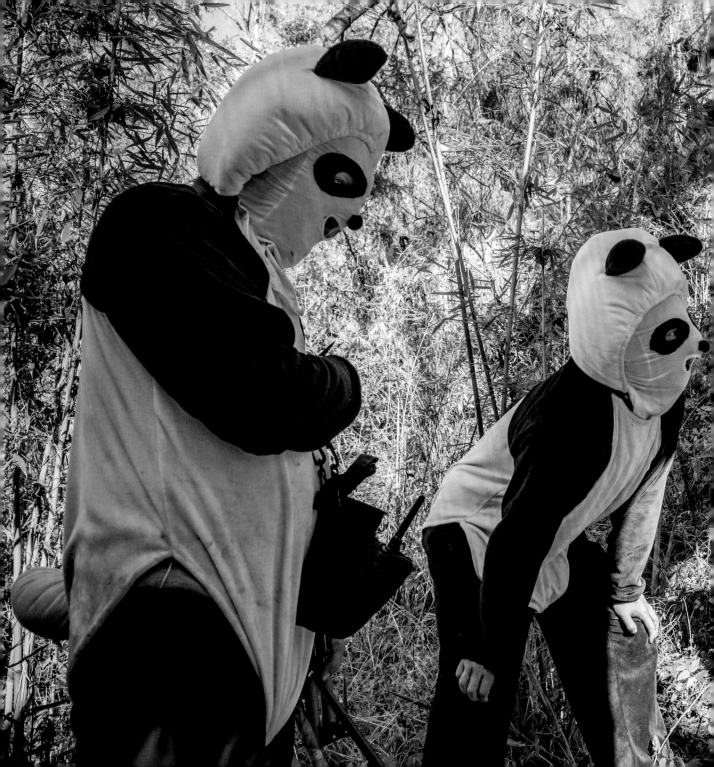

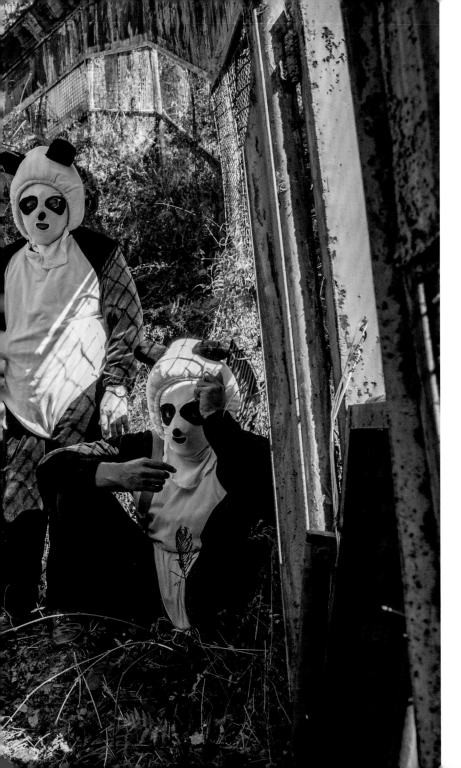

Why release pandas into the wild? The non-profit, Pandas International say, 'The answer lies in genetics. With any population, genetic diversity is the key to adaptation and survival. By introducing new genetic code into the wild population there is a greater chance of long-term viability. The reintroduction program, combined with programs to protect the habitat of extant panda populations is our best chance at ensuring a wild panda population recovery and continued species survival.'

A cub remains with its mother over the first two years of its life, and while in her care, he or she is eased toward wildness. After a year or so, the pair is moved to a large, fenced-in habitat up the mountain where the mother can continue coaching her offspring until the youngster is released – if deemed fit for freedom. To qualify, a young panda must be independent – wary of other animals, including humans; and capable of finding food and shelter un-aided.

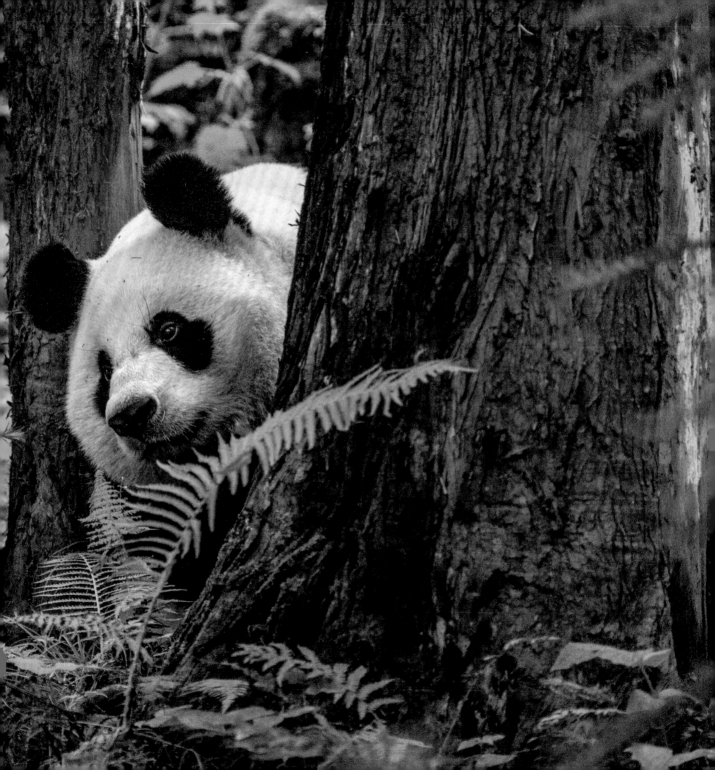

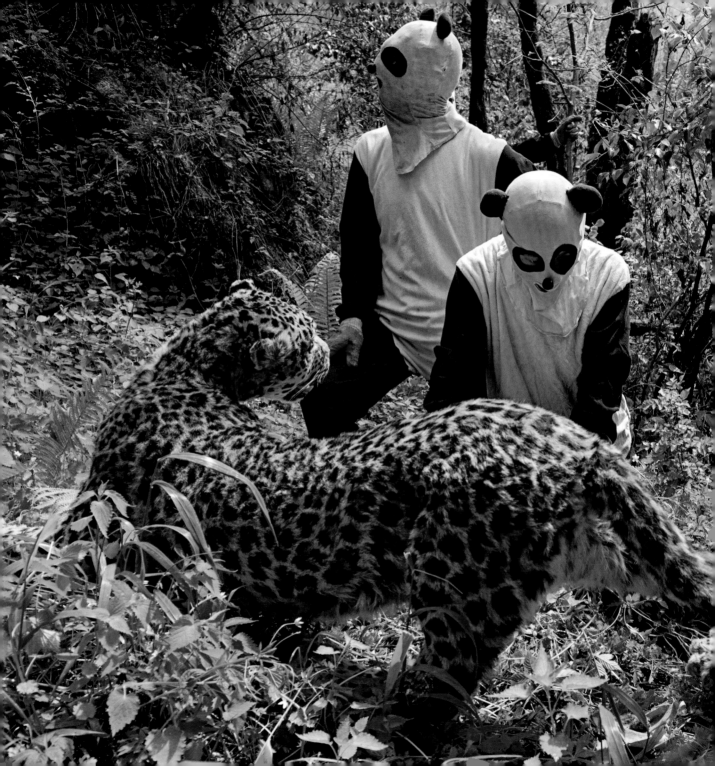

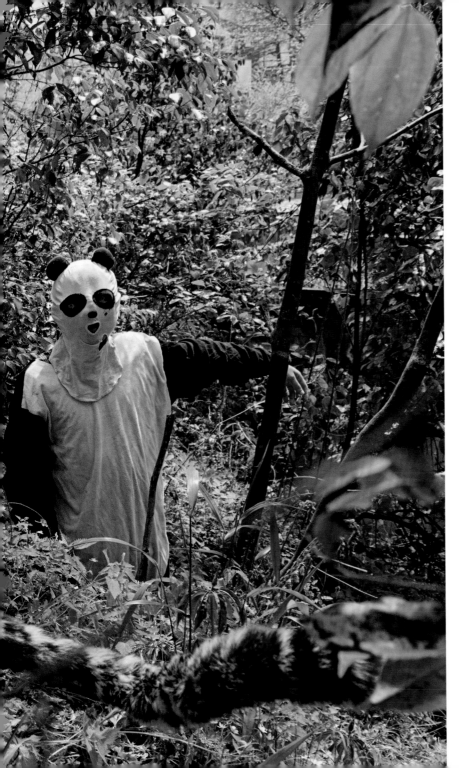

Here, a stuffed leopard is brought inside an enclosure and an audio recording is played of a growling leopard. If the panda runs up a tree, she passes the test, and is released into a larger enclosure.

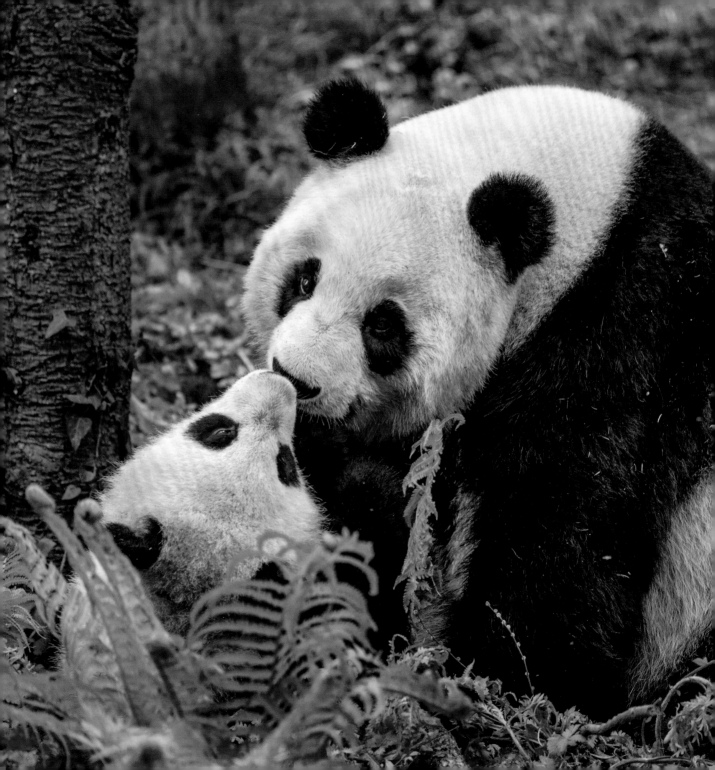

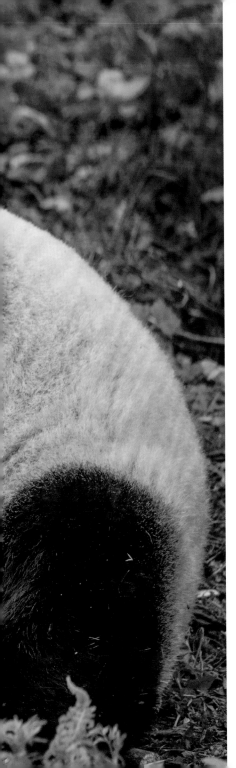

The nation of China is on its way to successfully saving its most famous ambassador and putting the wild back into an icon.

As adolescents, the pandas are frequently found nestled for days at a time, high up in the top boughs of trees, stashed by their mothers for safety.

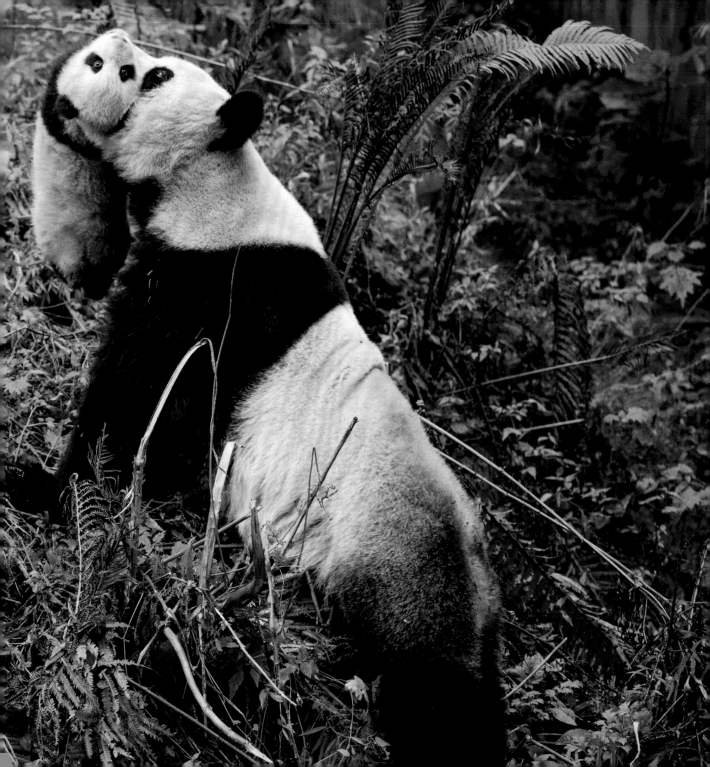

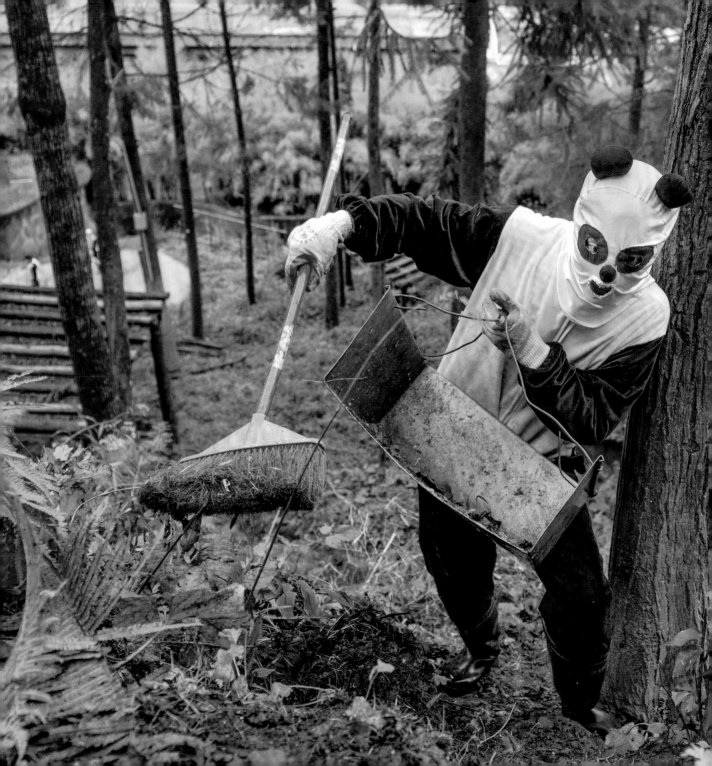

At Wolong Nature Reserve's Hetaoping Panda Center, bears being trained to live in the wild must not get used to seeing humans. Even the caretakers who clean the animals' cages wear costumes that make them look (and smell) like pandas.

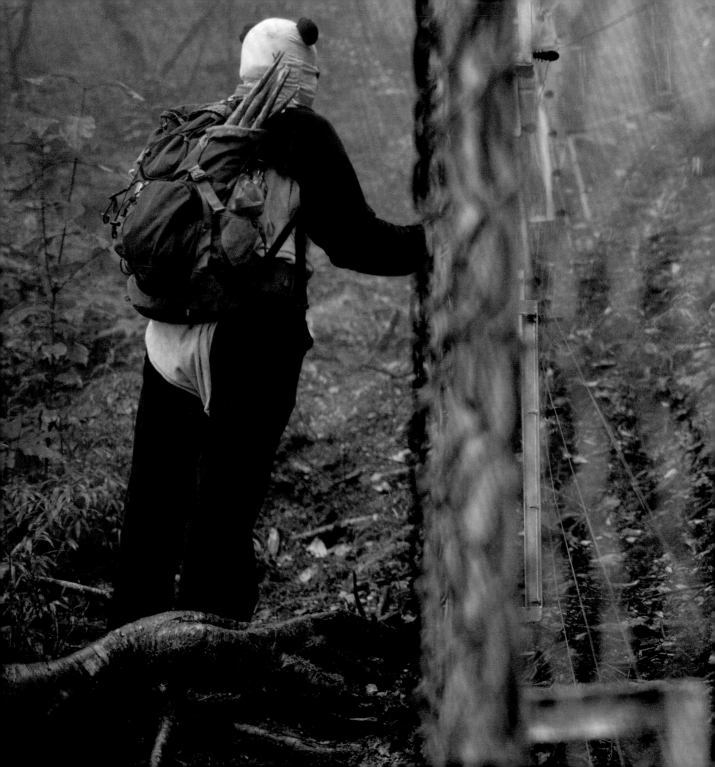

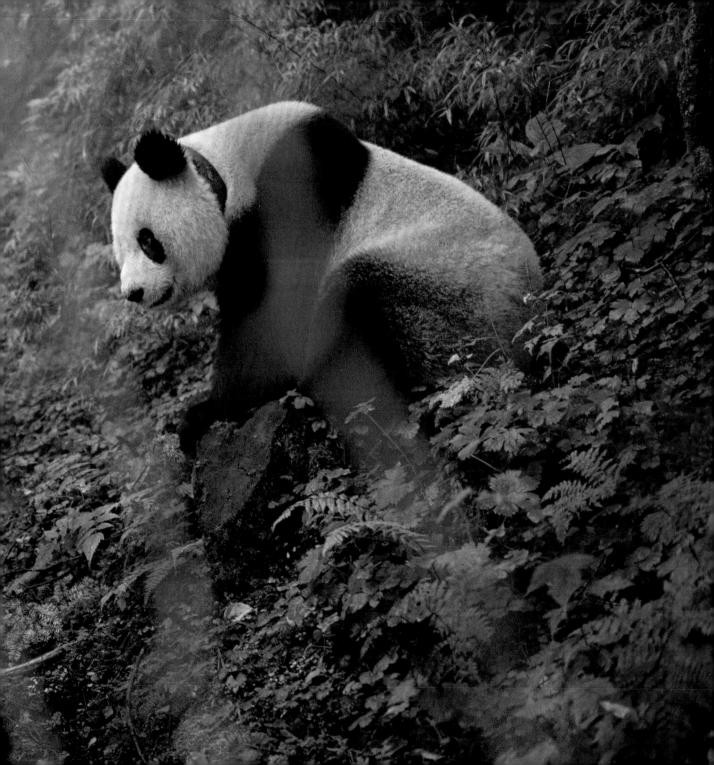

The keepers at Wolong Nature Reserve transport Hua Jiao (Delicate Beauty) for a health check before she finishes 'wild training.' The habitat also protects red pandas, pheasants, tufted deer and other species that benefit from giant panda conservation efforts.

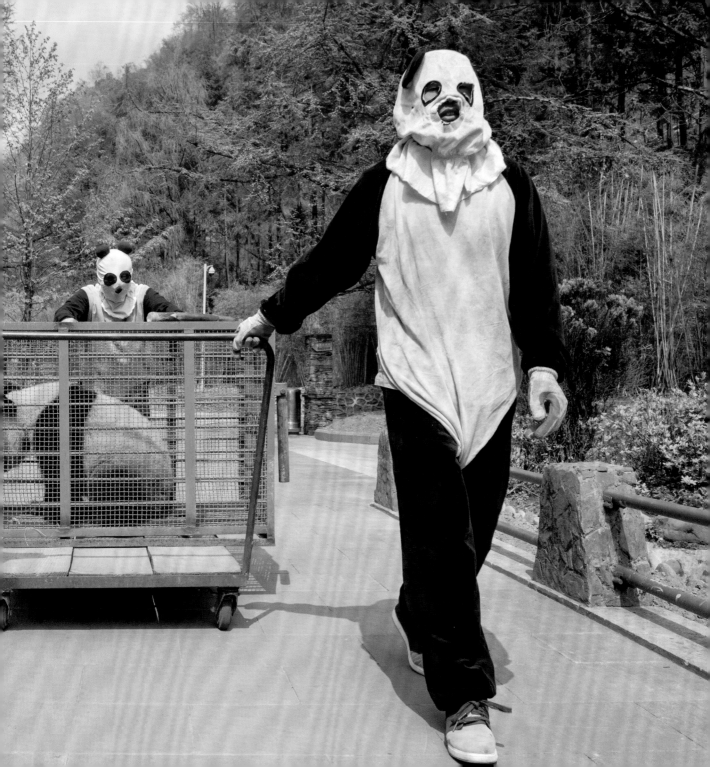

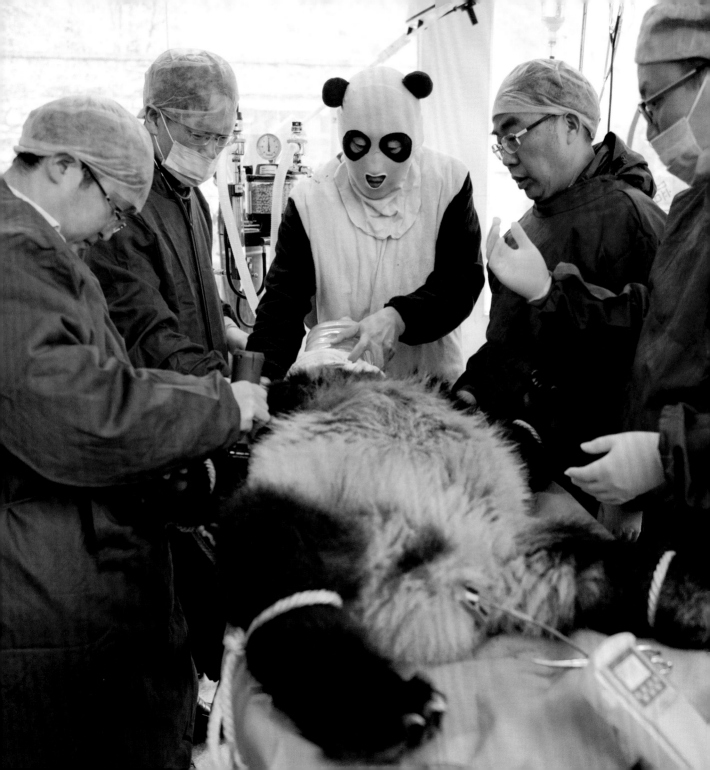

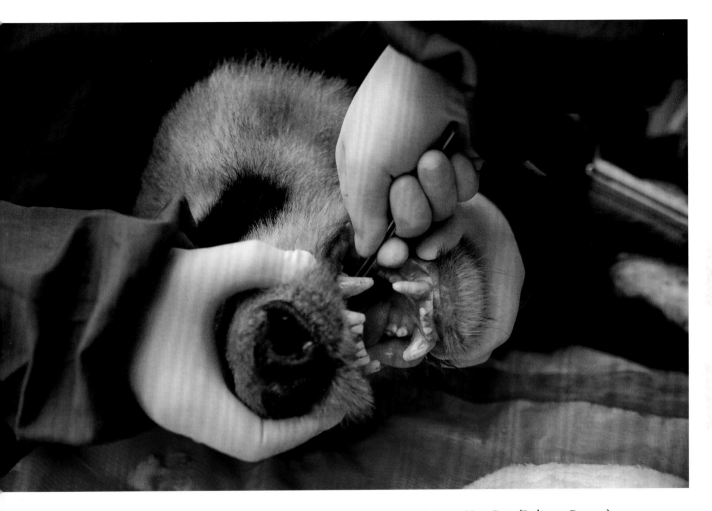

Hua Jiao (Delicate Beauty) is declared in good shape and ready for release after a thorough physical examination at the China Conservation and Research Center for the Giant Panda (CCRCGP).

Director Zhang Hemin and his staff put a radio collar on Cao Cao, a 13-year-old giant panda who is going to be released with her one-year-old cub, Hua Jiao (Delicate Beauty), into a bigger enclosure in higher altitudes for the third and final stage of wild panda training at Wolong Nature Reserve and China Conservation and Research Center for the Giant Panda (CCRCGP). Hua Jiao is the fifth captive panda that was released into the wild.

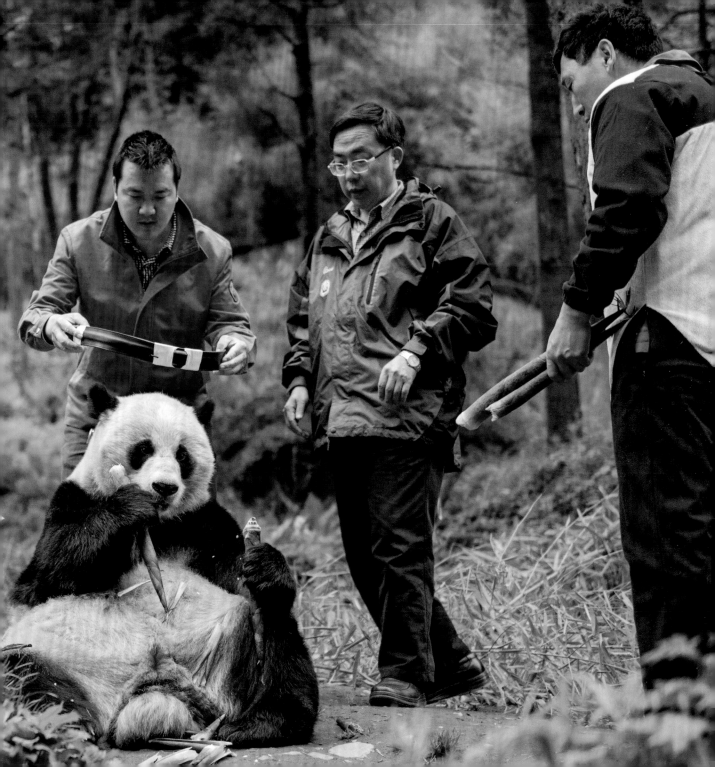

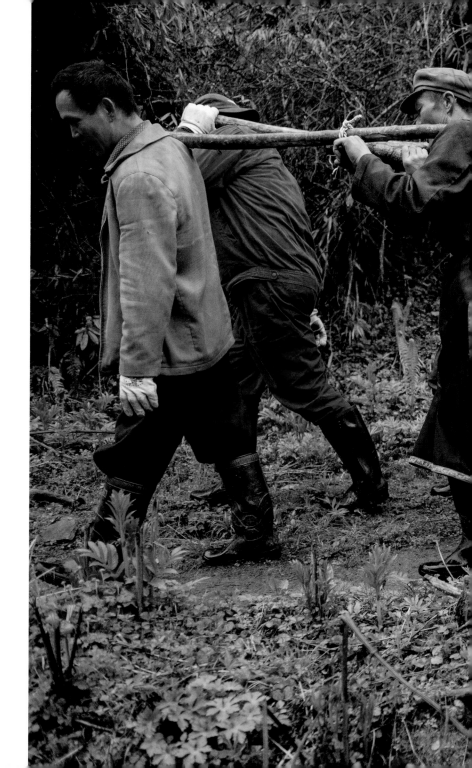

Over four days, Hua Jiao (Delicate Beauty) is given a final health check, fitted with a collar, crated and driven 200 miles to the Liziping Nature Reserve. It has good bear habitat and a small panda population.

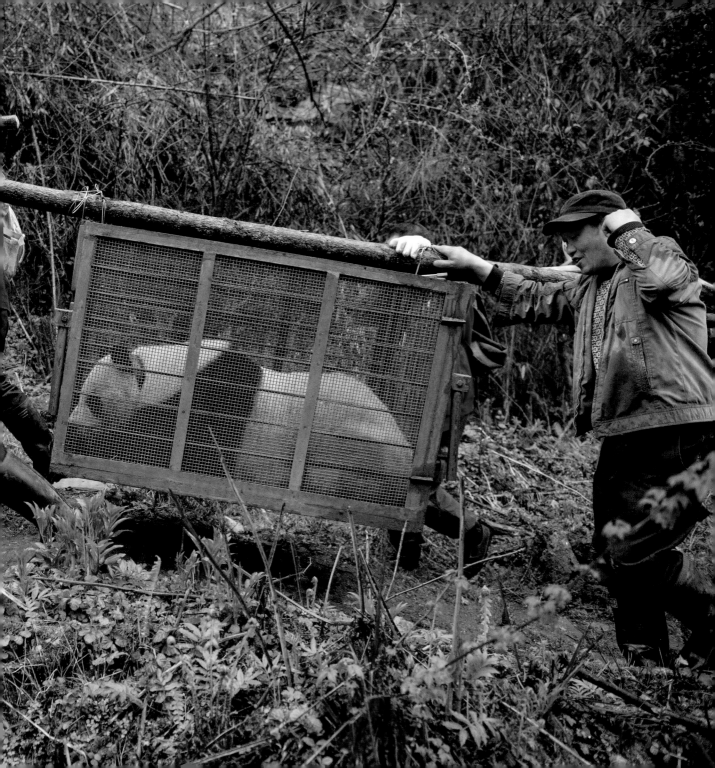

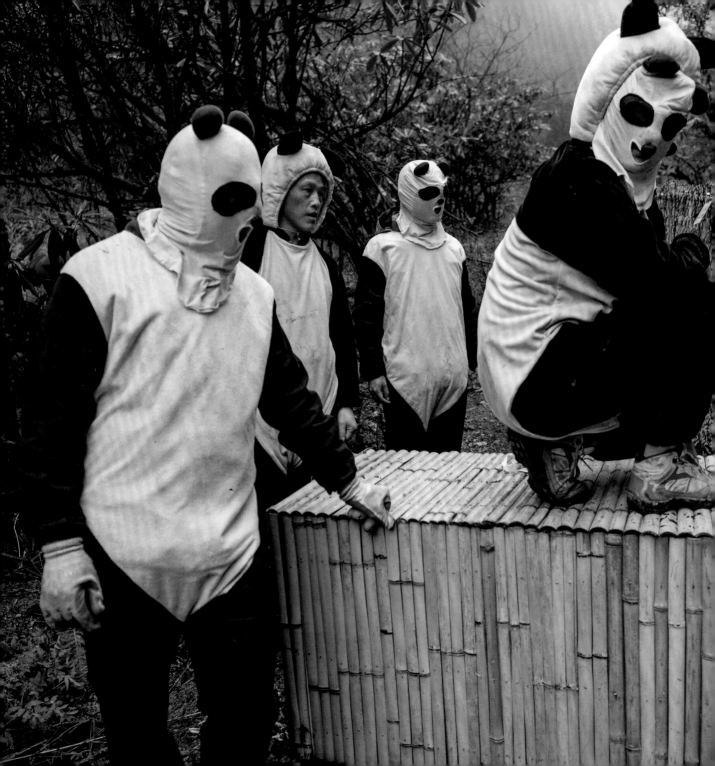

'Without help, the wild panda groups may die out within a century', says Huang Yan, who is the deputy chief engineer of the China Conservation and Research Center for the Giant Panda (CCRCGP) and is in charge of the wilderness-training programme.

Panda keepers Ma Li and Liu Xiaoqiang listen for radio signals from a collared panda training to be released to the wild. Tracking can tell them how the cub is faring in the rougher terrain up the mountain.

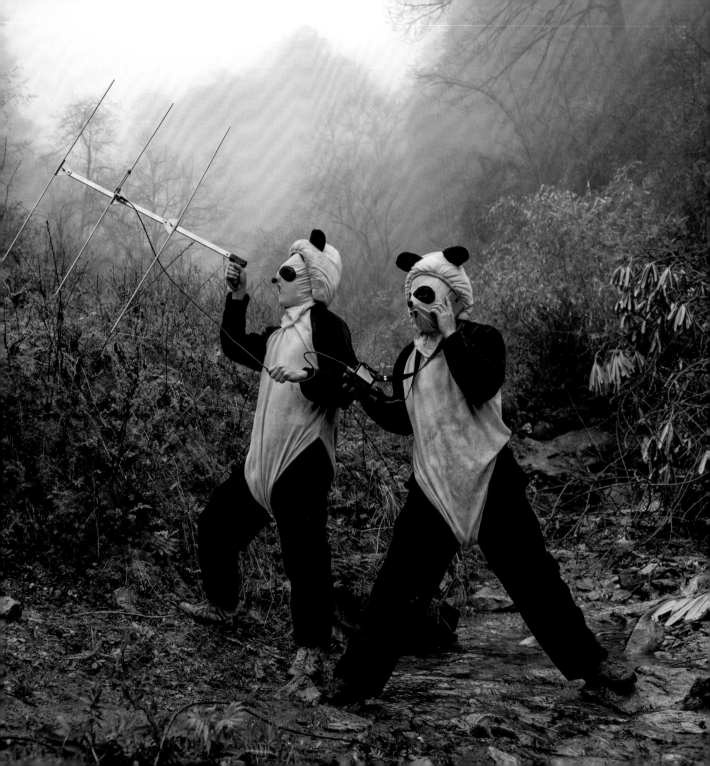

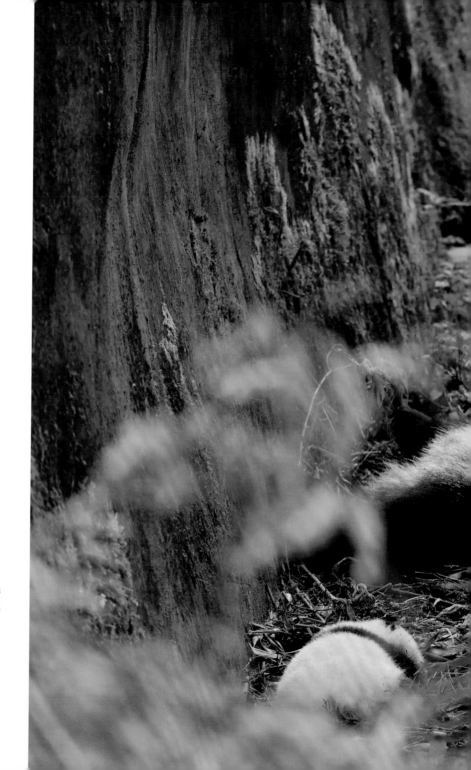

Director of the China Conservation and Research Center for the Giant Panda (CCRCGP), Zhang Hemin, names each new enclosure after a school and the biggest one is called Harvard. If successful the pandas get to graduate to the wild.

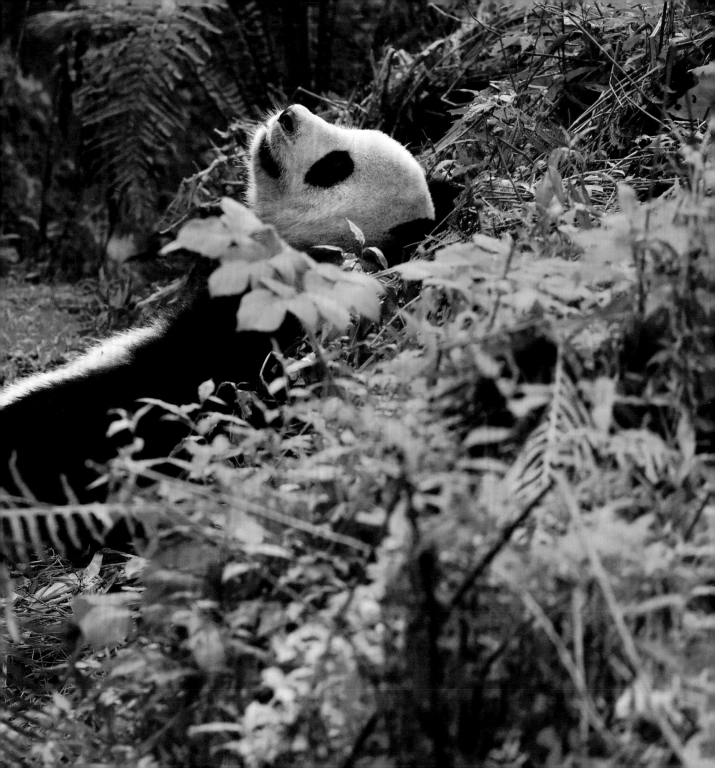

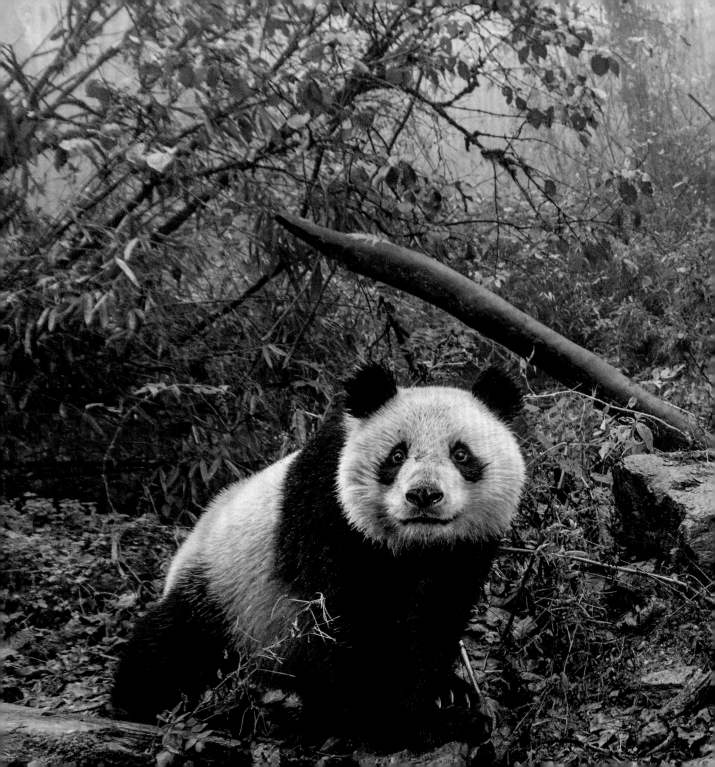

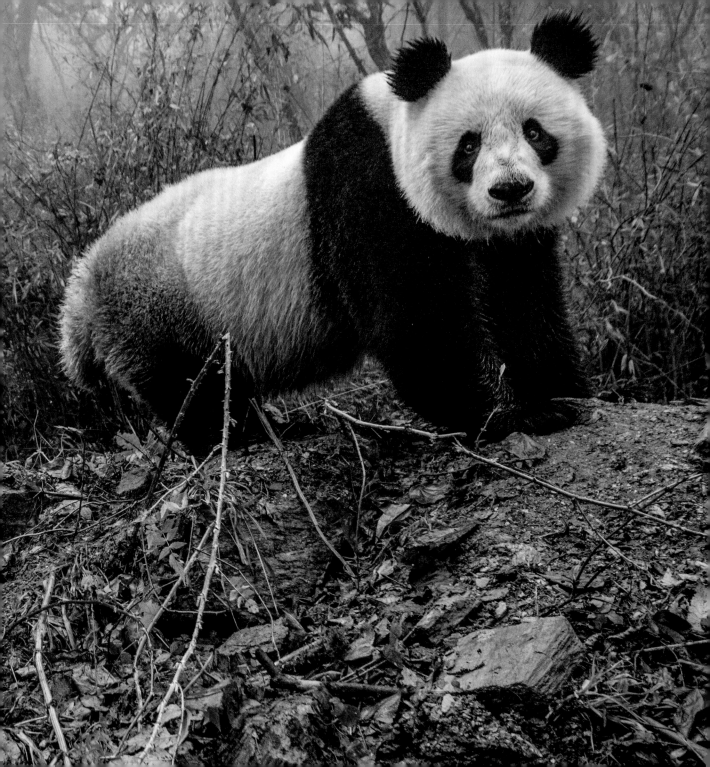

Giant pandas are masters of adaptation. 'We humans are used to changing the environment to suit our needs,' says Zhang Hemin, director of the China Conservation and Research Center for the Giant Panda (CCRCGP). 'The difference is that pandas changed themselves to suit the environment.'

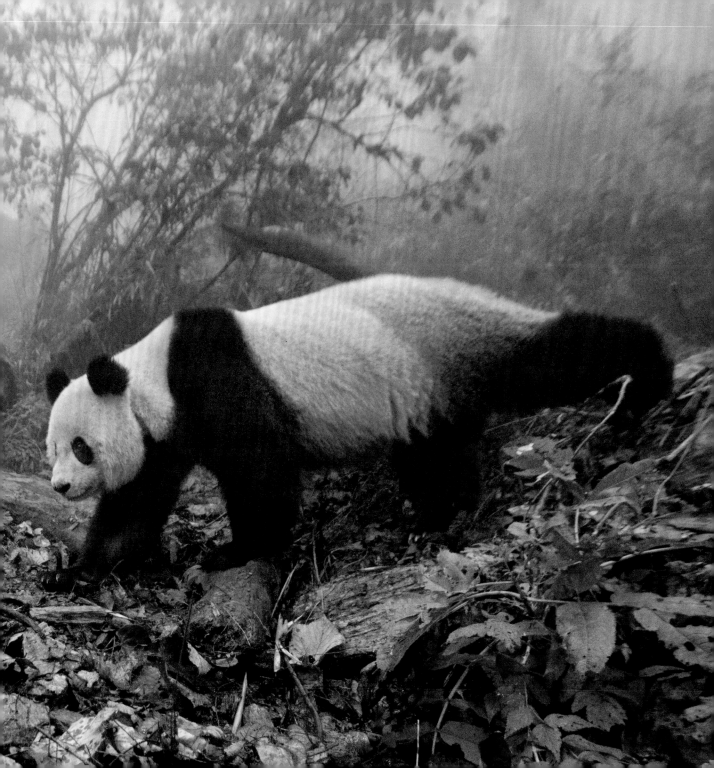

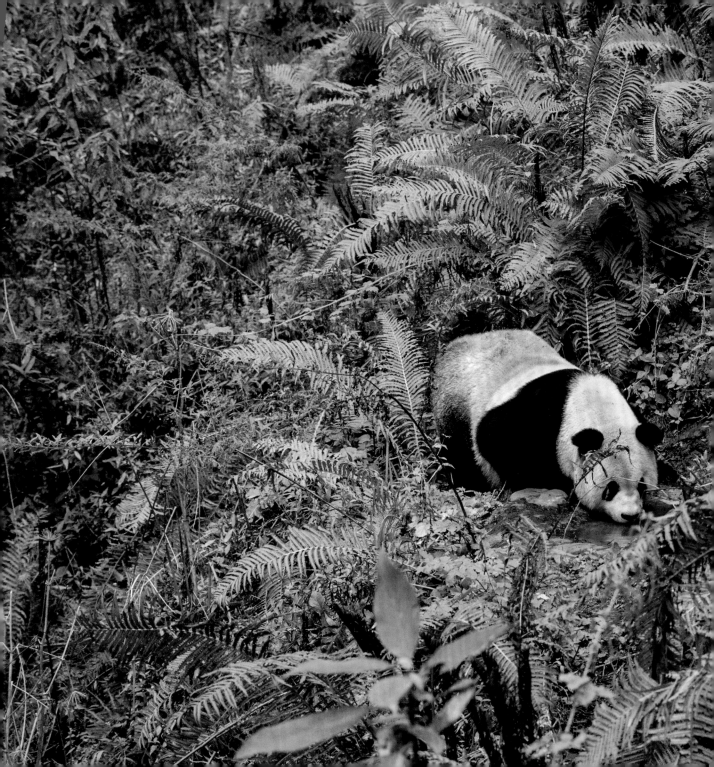

Trained and ready for freedom, Zhang Xiang (The Thoughtful One) takes her first steps into the Liziping Nature Reserve in 2013. She was the first female released since re-introductions began – and judging from her tracking-collar signals, she's doing just fine.

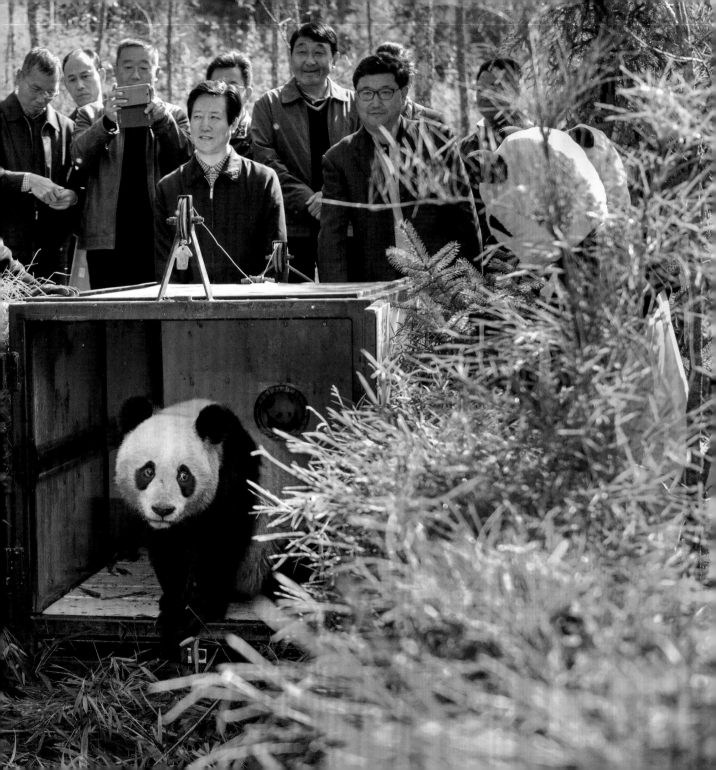

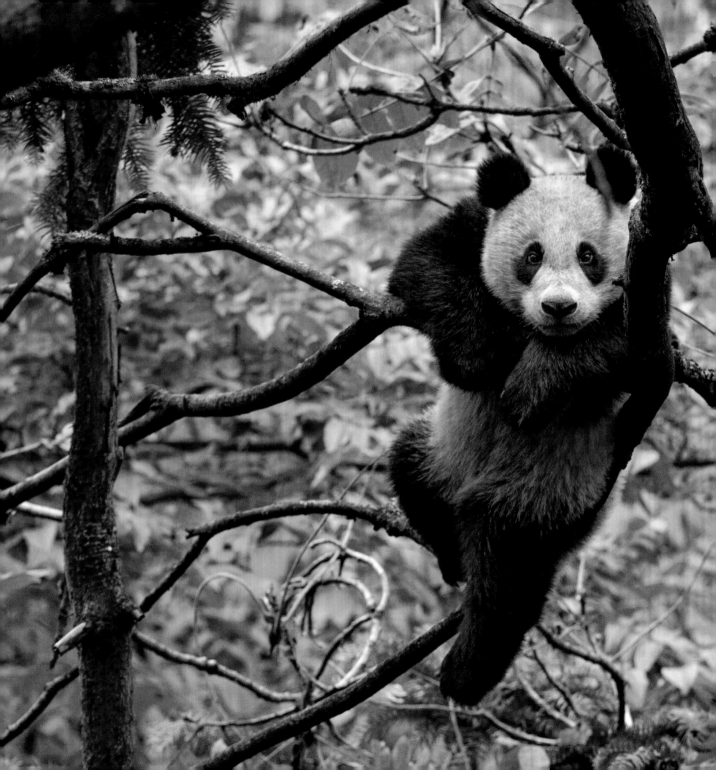

The panda reminds us that nature is resilient but we *have* to give it a chance to succeed. Now, the question is, how do we turn this incredible story of success into a solution to the larger problem – which is the long-term survival of ALL endangered species, as well as the preservation of ecosystems that sustain them.

This is a rare moment when a panda keeper in costume does a quick two-month health check on a cub at Wolong Nature Reserve in Sichuan Province, China. He first must carefully wait for the mother panda to leave while she forages for food and then quickly weighs and checks the cub. Because these pandas will be released back into the wild, the interaction with the keepers is very limited.

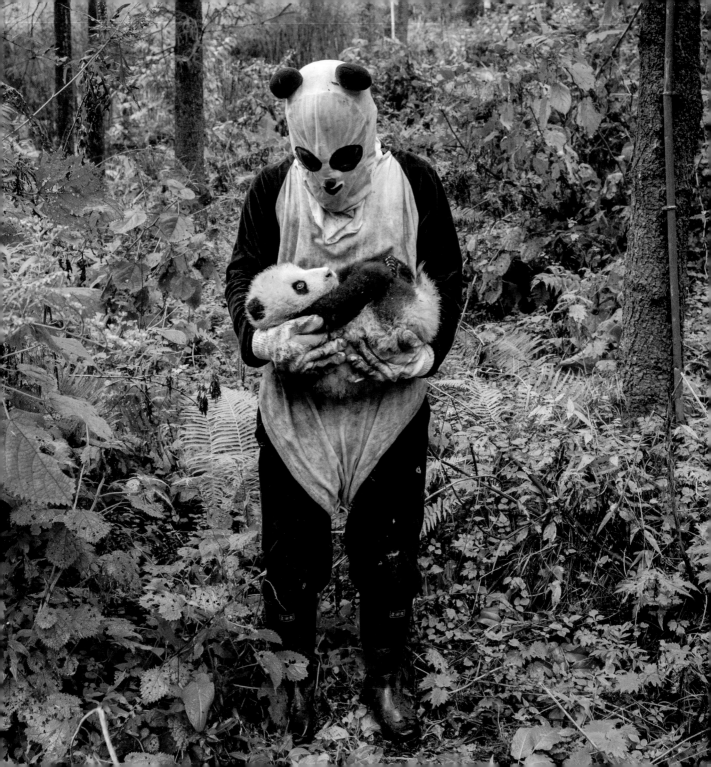

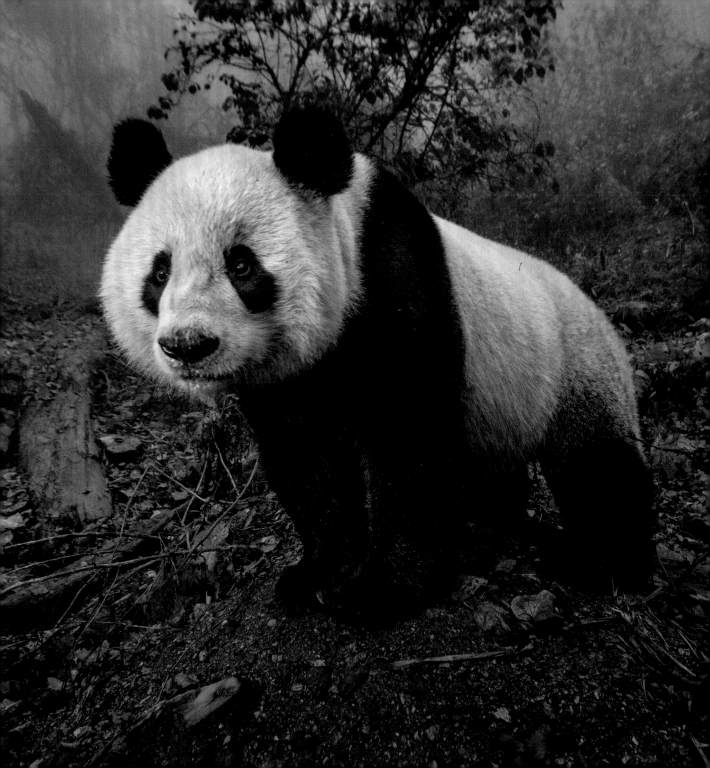

Acknowledgements

I've discovered a level of commitment to this gentle but vulnerable species that gives me hope at a time when hope for wildlife is in short supply. Such devotion starts with the tireless and beloved Zhang Hemin, better known as 'Papa Panda,' the director of all things related to black-and-white-bear breeding and conservation at the China Conservation and Research Center for the Giant Panda (CCRCGP).

I'd like to acknowledge research head and centre expert Li De Sheng, the heads of the Bifengxia Giant Panda Base – Zhang Gui Quan, as well as the head of the Wolong Nature Reserve – Huang Yan and Junior head Wu Dai Fu for their enormous help in understanding panda behaviour.

I'll also tip my hat in special thanks to Gao Xiao Wen and Jade Xia, who spent countless hours over the years getting me the access to make the images that tell the pandas' stories.

Dedication to giant pandas happens at every level, from the animal keepers who lug truckloads of bamboo to the hungry mother bears to those who pull on their panda costumes day after day at the Wolong Nature Reserve to stay 'hidden' among the animals in their care. It comes from local biologists who camp out in panda territory, where they help prepare semi-wild bears for life in their natural habitat, and from caretakers who embrace baby pandas as family, making sure the most fragile cubs don't just survive but thrive. There are countless others – the pandas' 'unsung heroes,' working toward the bears' well-being both in captivity and in the wild. Unable to name them all here, I remain grateful for their many efforts.

Stepping back further, I'd also like to express my appreciation to the scientists studying the basics of panda behaviour to improve the chances for successful reintroduction, and for those in scientific and policy-making roles, who are fighting to protect the natural ecosystems that wildlife requires. The work to understand this species and its environment goes back many decades, to field researchers whose efforts early on founded the base of knowledge on which today's breeding and conservation successes stand.

Saving giant pandas will continue to require an outsize team of talented, caring people, and I'm extremely confident in their ability to keep pandas thriving in the wild. That includes those who love this species from afar and offer their support through education, donations, and other means – all vital to the cause. The conservation-minded individuals helping pandas are in turn working to ensure a kinder, healthier, and more beautiful world for our own species. I am honored to follow them in this pursuit.

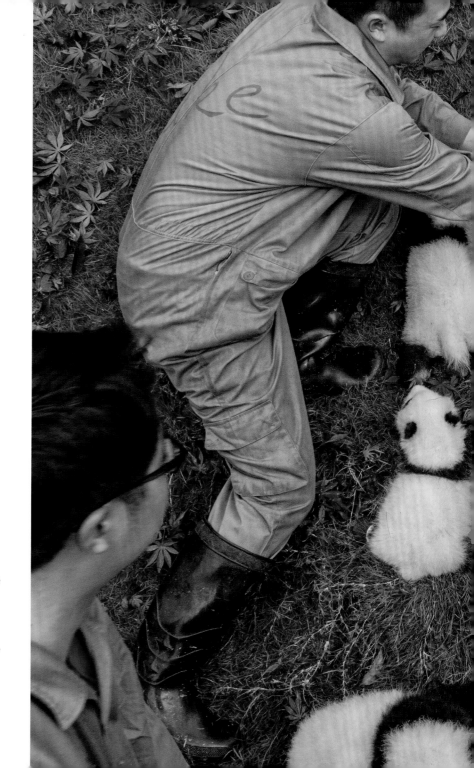

This book is dedicated to Zhang Hemin – 'Papa Panda' to his staff (photo opposite shows him posed with cubs born in 2015 at the Bifengxia Giant Panda Base.) 'Some local people say giant pandas have magic powers,' says Zhang, who directs many of China's panda conservation efforts. 'To me, they simply represent beauty and peace.'

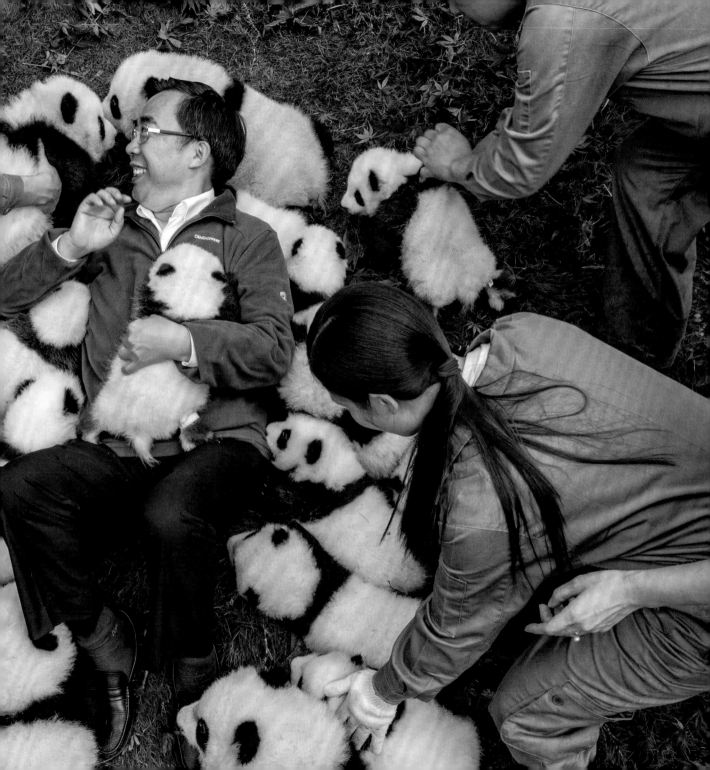

First published in 2018 by Hardie Grant Books,
an imprint of Hardie Grant Publishing

Hardie Grant Books (London)
5th and 6th Floors
52–54 Southwark Street
London SE1 1UN

Hardie Grant Books (Melbourne)
Building 1, 658 Church Street
Richmond, Victoria 3121

hardiegrantbooks.com

British Library Cataloguing-in-Publication Data. A catalogue
record for this book is available from the British Library.

ISBN: 978-1-78488-127-6

Publisher: Kate Pollard
Commissioning Editor: Kajal Mistry
Senior Editor: Molly Ahuja
Publishing Assistant: Eila Purvis
Design: Nicky Barneby
Photo Retouching by Butterfly Creative Services
Colour Reproduction by p2d

Printed in China by C&C Offset Printing Co., Ltd.